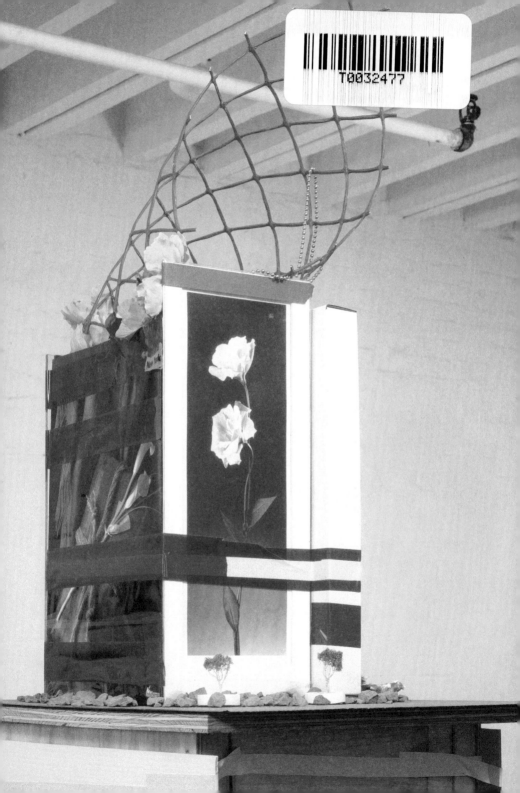

Cover and opening page: Isa Genzken, *Fuck the Bauhaus #2* (detail), 2000, plywood, plastic, paper, cardboard, pizza box, plastic flowers, stones, tape, model trees, toy car, 210 × 70 × 51 cm

Final page: Isa Genzken, *Fuck the Bauhaus #4* (detail), 2000, plywood, plexiglass, plastic, clipboards, aluminium lampshade, flower petals, tape, printed paper, shells, model tree, 224 × 77 × 61 cm

Isa Genzken
Fuck the Bauhaus

by
André Rottmann

Afterall Books ONE WORK

Isa Genzken:
Fuck the Bauhaus
by André Rottmann

First published in 2024
by Afterall Books

ONE WORK SERIES EDITORS
Elisa Adami
Wing Chan
Mark Lewis

MANAGING EDITOR
Elisa Adami

ASSISTANT EDITOR
Wing Chan

COPY EDITOR
Deirdre O'Dwyer

DESIGN
Emily Schofield

Printed and bound by
die Keure, Belgium

The One Work series is printed
on FSC-certified papers

ISBN 978-1-84638-253-6

Distributed by
The MIT Press
Cambridge, Massachusetts and London
www.mitpress.mit.edu

AFTERALL
Central Saint Martins
Granary Building
1 Granary Square
London N1C 4AA
www.afterall.org

Afterall is a Research Centre of
University of the Arts London and
was founded in 1998 by Charles Esche
and Mark Lewis.

DIRECTOR
Mark Lewis

ASSOCIATE DIRECTORS
Chloe Ting
Adeena Mey

PROJECT COORDINATOR
Camille Crichlow

Each book in the *One Work* series presents a single work of art considered in detail by a single author. The focus of the series is on contemporary art and its aim is to provoke debate about significant moments in art's recent development.

Over the course of more than one hundred books, important works will be presented in a meticulous and generous manner by writers who believe passionately in the originality and significance of the works about which they have chosen to write. Each book contains a comprehensive and detailed formal description of the work, followed by a critical mapping of the aesthetic and cultural context in which it was made and that it has gone on to shape. The changing presentation and reception of the work throughout its existence is also discussed, and each writer stakes a claim on the influence 'their' work has on the making and understanding of other works of art.

The books insist that a single contemporary work of art (in all of its different manifestations), through a unique and radical aesthetic articulation or invention, can affect our understanding of art in general. More than that, these books suggest that a single work of art can literally transform, however modestly, the way we look at and understand the world. In this sense, the *One Work* series, while by no means exhaustive, will eventually become a veritable library of works of art that have made a difference.

CONTENTS

André Rottmann is an art historian based in Berlin and Assistant Professor for Art and Media Theory at the European University Viadrina Frankfurt (Oder), Germany.

ACKNOWLEDGEMENTS

In the lengthy process of thinking and writing about the sculptural assemblages of Isa Genzken, I was most fortunate to have repeatedly had the opportunity to exchange ideas and arguments with Benjamin H.D. Buchloh; his encouragement and friendship continue to be invaluable. At an early moment of the project, artist Paul Chan corroborated my intuition that Genzken's more recent architectural models could indeed be approached in terms of Adornian 'late style'. Tom Holert gave important impulses and generously shared his own research concerning the history and theory of models. An invitation by Tobias Vogt and Antje Krause-Wahl to present an early draft of this material at a conference on assemblage at the Goethe-Universität in Frankfurt (Main) was as crucial as it was productive in further shaping the theoretical framework of this study. I wish to thank Galerie Buchholz in Cologne, especially Katharina Forero, for providing archival resources and most of the images included in this monograph. At Afterall, Gaia Alessi and Caroline Woodley initiated this publication and I am grateful for their interest and willingness to include my book in the *One Work* series. Elisa Adami has been the most patient, prudent and precise editor imaginable and I wish to warmly thank her for all her work and efforts. Many thanks are also due to Deirdre O'Dwyer for her thoughtful and attentive copy-editing of this book. Lastly, my most heartfelt thanks are reserved for Franziska Brons and Eliot, without whom all of this would be unthinkable.

In hindsight, Isa Genzken's work seems to bifurcate at the turn of the twenty-first century. Until that period, the artist's practice had been mostly grounded in defined and cohesive forms of engaging and addressing architecture and (urban) space. Recurring forays into photography, film, books and collage notwithstanding, Genzken's art had been particularly rooted within the distinguishable domain and conventions of sculpture. Evoking selected fragments, at times ruins, as well as entire structures of the built environment, such as doors and windows, train stations and gallery spaces, through the presence and attenuated gestalt of scaled sculptures, she had perfected an elaborate syntax of non-objective shapes and a comprehensive lexicon of materials, notably plaster, concrete, wood and epoxy resin. Emerging in the mid-1970s as part of the Rhineland art scene of West Germany, her artistic language revealed an indebtedness to (post-) Minimalism and its European reception since the late 1960s. However, at the beginning of the new millennium, her grammar started changing. All of a sudden, or so it seemed, Genzken's work became almost exclusively predicated on the accumulation of readymades in sprawling yet exacting assemblages. 'Drawing things together' from different, if not irreconcilable, areas and morphologies of everyday life in commodity and media culture, the post-2000 works register as almost incompatible with the artist's preceding production.

This apparently startling turn — away from a long-honed (post-)Minimalist and at times Conceptual and Constructivist sensibility in the creation of abstract, permutational, self-contained and chromatically subdued aesthetic objects, towards a penchant for precarious sculptural amalgamations of items and images foraged from various sources — hardly announced itself with grandeur or grandiosity. It became fully visible in a perhaps fittingly lapidary and casual form during a crisis-ridden and conflictual moment of Genzken's not at all carefree route in art (and life). Retrospectively, the major transition within her fifty-year artistic trajectory can be traced back to when she first exhibited the group of six sculptures called *Fuck the Bauhaus* (all works 2000).[1] For their first exhibition, at the now defunct AC Project Room in New York in the autumn of 2000, the polychrome formations of *Fuck the Bauhaus* were elevated to eye level on makeshift

plywood pedestals arranged in two parallel rows of three works each (fig.8, 9). The artist had gathered or acquired the works' cheap materials and readymade objects while strolling through Manhattan, and she assembled them to create ostentatiously ornamental architectural models for future high-rises. On the one hand, these 'New Buildings for New York', as the secondary title of Genzken's comparatively small exhibition dubbed them, followed from a lineage that includes some of her earlier sculptural evocations of the built environment. Time and again, she had resorted to the architectural model, informed and influenced — at least in the beginning — by (male) artists in her vicinity (such as Thomas Schütte and the entire Düsseldorf-based group colloquially called 'model makers') who were equally interested in precedents of European avant-garde practice and design culture. By 2000, the model had repeatedly served her and others as a matrix of sculpture in the wake of both Minimalism's abstract, formal and phenomenological address of the spaces of aesthetic experience, and post-Minimalism's experimental and *informe* preoccupations with the contingencies of production processes, matters and materials. On the other hand, these new works confronted viewers in an utterly unforeseeable manner, as aggregations that defied the conventions of exactly those two salient strands in postmodern sculpture.

Created in a rapid but not at all impulsive or negligent manner, the *Fuck the Bauhaus* sculptures unapologetically combine heterogenous items. For instance, *Fuck the Bauhaus #1* (fig.1) includes a toy car, a shell, a mirror piece and a sheet of textured glass, while *Fuck the Bauhaus #2* (fig.2) features a piece of cardboard, a pizza box, plastic flowers, a warped piece of construction-site netting, stones, found photographs, a shopping bag and model trees. *Fuck the Bauhaus #3* (fig.3) throws into relief oyster shells, a piece of metal foil and plastic bars; *Fuck the Bauhaus #4* (fig.4) brings together a Slinky, clipboards, an aluminium lampshade, flower petals, plexiglass and printed matter; *Fuck the Bauhaus #5* (fig.5, 6) tops assorted metal discs with an antenna-like protuberance of red tape; and finally, *Fuck the Bauhaus #6* (fig.7) presents nothing more than a propeller stuck on metal discs.[2] The six vertical bricolages are held together, like the sections of the plywood pedestals, only by strips of messily applied, colourful tape, often vinyl.

Across a wall of AC Project Room's modest and unrenovated exhibition
space, untitled and unframed black-and-white photographs of details taken
of the façades of skyscrapers were additionally on display. A film with
a runtime of 31 minutes, for the most part without sound, was projected
as a loop onto the ceiling above *Fuck the Bauhaus #3*. Prosaically titled *Work*
(2000), the film shows a sunset seen from Manhattan, looking across the
Hudson River towards New Jersey; in some sequences, the sunlight is only
visible as a mere reflection on the window of a corporate office building,
where a white-collar worker in a cubicle stares at a flickering computer
screen. *Fuck the Bauhaus #5* additionally comprises a small-scale battery-
powered plastic hula dancer which, placed directly on AC Project Room's
floor, danced intermittently, as if to animate the above avenue of
unapologetically extravagant building blocks — a mockery miniature of
a public monument *en abyme*.[3]

The title of Genzken's series flippantly opposes her sculptures to the
progressive architecture and design of European avant-gardes in the interwar
period (and after the Second World War), as epitomised by the legendary
Dessau-based interdisciplinary art school. Yet, in these heterogenous
ensembles, the technology-inspired ideals of dynamism, transparency and
modularity associated with the Bauhaus vision are deliberately superseded
by an enforced collision of the banal with the bewildering, the redundant
with the rare, the excessive with the elaborate, the energetic with the elegant,
the flamboyant with the filigree. In her study of the artist's career, *Isa
Genzken: Sculpture as World Receiver* (2017), art historian Lisa Lee emphasises
what she regards as Genzken's earnest engagement with Walter Gropius's
ideas for reform in modern architecture and argues that in *Fuck the Bauhaus*
she 'simultaneously pays tribute to and takes the air out of whatever was
utopian in the concept of prefabricated housing for the masses'.[4] Furthermore,
despite 'the impoverishment of means and materials' and the obvious
dissimilarities between this series, based on the 'recombination of mass-
produced elements', and Genzken's former works made of plaster or concrete,
Lee stresses the continuity of a critical and analytic approach to urban space
that tends to be obscured in the perception of the 'breezy insouciance and
humor of her assemblages'.[5] The artist's sustained interest in the architectural

model and attendant concerns with the dystopia and utopia of habitation and dwelling in modernity is indeed as remarkable as her evident awareness of historical genealogies. But, if means and materials do matter in art (as elsewhere), these wayward assemblages, and their formation, meaning and significance, should be further contextualised and conceptualised both within the artist's broader oeuvre and within a framework that clarifies their importance for understanding current developments in contemporary art.

Before *Fuck the Bauhaus*, the artist's sculptures had displayed an almost classical repertoire of techniques — modelling and mounting, carving, casting and chiselling amongst them. In instances such as her *Ellipsoids* and *Hyberbolos*, sinuous and stereometric wooden floor pieces that she produced from the mid-1970s to the early 1980s, these techniques were supplemented by Genzken's early use of computers in the design process. Invariably, the result is an aesthetic object stressing the traditional facets of mass, weight, volume and texture. That is, Genzken was engaging with the preeminent concerns of modern sculptors from Constantin Brâncuşi to Richard Serra. As of 2000, this safeguarded (though masculinist) approach and orientation was supplanted by brash, occasionally even brute gestures of juxtaposing, stacking, arranging and distributing a virtually inexhaustible panoply of objects, devices and materials (which, one might argue, implies more ambiguous gender politics). If still primarily dealing with sculptural traditions, these assemblages are more reminiscent of tactics of montage as conceived by Hans Arp, Hannah Höch, Kurt Schwitters and others in the historical contexts of Dada and related strands of the European avant-garde.

Apparently signalling a profound break within the development of Genzken's own procedures and preoccupations up to this point, this altered aesthetic of assemblage is indicative of a change in sculptural practices and epistemes that goes beyond the confines of any individual work. At first glance, it seems to corroborate the irrevocable validity of the Duchampian paradigm and its belated effects on art from the twentieth century onwards. The history and theory of Western sculpture since Auguste Rodin by definition (or default) presupposes, albeit to varying degrees, an expansion or fracture of the medium's (always already) imaginary integrity and essence. The reasons for such signs of a subversion of sculpture are various: from

the introduction of technologies of industrial production and reproduction (undermining ideals and ideas of manual skill and individual originality), to the concomitant onslaught of the commodity form on the tenets of sculptural ingenuity (for instance, in the proposition of the Dada readymade in the 1910s, and in the subsequent claims for the affective or libidinally charged surrealist *objet trouvé*), to the programmatic fraying of the boundaries between art and architecture (notably in Soviet Constructivism and its legacies, all the way to Minimalism's upending of formalist aesthetics).[6]

Art historian Rosalind E. Krauss's 1978 essay 'Sculpture in the Expanded Field' famously gauges the consequences of sculpture's utterly reshaped material supports and spatial relations, claiming that after modernism's eclipse at the end of the 1960s, the medium could only be approached in terms of a series of negations. In works by artists such as Richard Long, Mary Miss, Robert Morris and Robert Smithson, the three-dimensional aesthetic object does not constitute an enclosed entity modelled after the ancestral logic of the monument (as a conjecture of place, materiality and form). Rather, as evidenced in the Greimasian diagram accompanying Krauss's essay, it presents a phenomenon — an axiomatic structure, a site construction or a marked site — that often only differs from the landscape or architecture in or next to which it finds itself located.[7] Arguably, in her most recent assemblages, not only does Genzken incorporate and probe into the manifold histories of her chosen and preferred medium based on its intricate rapport with architecture's spatialised forms, social promises and political failures. She also intensifies the inherent dynamics of sculpture since modernity, towards disintegration, virtually to the point of implosion, pushing the artistic field of plasticity into hitherto uncharted territory.

Over the last twenty years, Genzken's reoriented practice has partaken in, or even been prompted by, what art historian Benjamin H.D. Buchloh — one of the artist's most engaged and insightful critics since the very inception of her practice — has clairvoyantly identified as sculpture's current becoming synonymous with the mere amassment, anomic accumulation and chaotic centrifugal assemblage of industrially prefabricated consumer goods; or, with the rubble and refuse of quotidian experience and existence *tout court*.[8]

Even when considering the plethora of anti-aesthetic strategies devised by the (neo-)avant-gardes from the 1910s to the post-War period, it is first and foremost Genzken's recent oeuvre that has developed and fully displayed such tendencies towards a deconstruction, perhaps even brazen undoing, of a once thoroughly delineated artistic medium. As Buchloh has suggested, these tendencies have been undeniably adopted by younger artists such as Rachel Harrison, Sarah Sze and Cathy Wilkes.[9] Aside from monographic interest, analysing Genzken's pioneering practice therefore could prove relevant for a deepened understanding of contemporary art as an omnipresent, yet much debated, art historical periodisation deemed distinct not only from modernism but also from postmodernism. Paying close attention to Genzken's pathways after Minimalism may help elucidate the terms, conventions and *modi operandi* of 'the contemporary' at large.[10] If, as philosopher Peter Osborne has claimed, contemporary art is organised mainly in the logical form of 'distributive unities', and hence critically mediates between individual works and the universality of Art through the principle of the series, Genzken's suite of unruly assemblages called *Fuck the Bauhaus* promises to be a particularly fertile ground from which to venture towards a theory of the art of our present.[11]

In the existing critical literature on Genzken's vast body of work, the particular shift from restrained construction to playful bricolage has repeatedly been deemed disruptive, as it risks unravelling the very fabric holding together the artist's previous sculptural method. In her review of Genzken's 2009 retrospective exhibition at the Whitechapel Gallery in London, art historian Briony Fer, for instance, on the one hand stresses the overall coherence, precision and critical importance of the artist's approach to sculpture since the 1970s. On the other, faced with the 'volatile mix of the voracious and the detached, the wayward and the reticent' in Genzken's most recent series of composites based on the accoutrement and arrangement of shop window mannequins (included in the installation *Strassenfest* (*Street Finds*), 2008–09), Fer cautions that occasionally Genzken's 'mayhem of recent years gets a little out of hand'.[12] Even Buchloh, in his initial assessment of the artist's novel aesthetics of assemblage in 2005, goes as far as to identify these works as articulations of a self that appears to have

fig.1

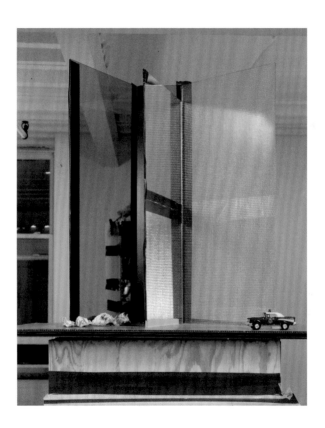

Isa Genzken, *Fuck the Bauhaus #1* (detail), 2000, plywood, mirror, textured glass, tape, net tape, vinyl adhesive, toy car, shell, 210×70×51cm

fig.2

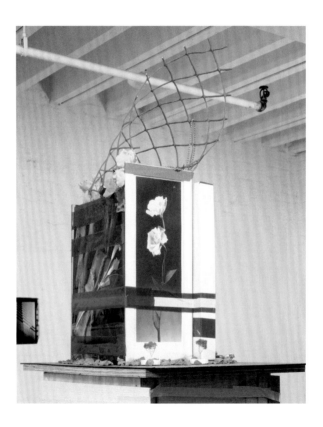

Isa Genzken, *Fuck the Bauhaus #2* (detail), 2000, plywood, plastic, paper, cardboard, pizza box, plastic flowers, stones, tape, model trees, toy car, 210×70×51cm

fig.3

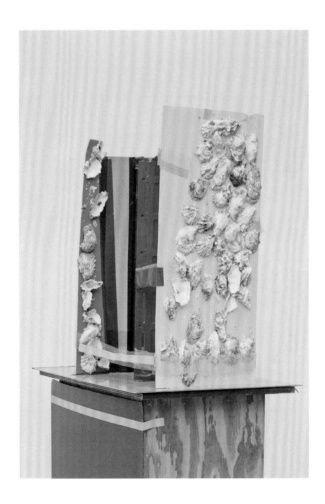

Isa Genzken, *Fuck the Bauhaus #3* (detail), 2000, wood, cardboard, glass, plastic, shells, tape, 210×70×51cm

fig.4

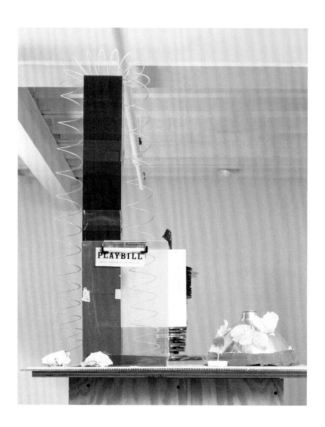

Isa Genzken, *Fuck the Bauhaus #4* (detail), 2000, plywood, plexiglass, plastic, clipboards, aluminium lampshade, flower petals, tape, printed paper, shells, model tree, 224 × 77 × 61 cm

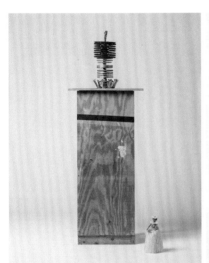
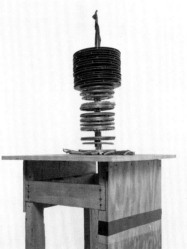

Isa Genzken, *Fuck the Bauhaus #5*, 2000, plywood, metal, plastic, fabric, adhesive tape,
doll, pedestal sculpture: 195 × 70 × 50cm, doll: 30 × 7 × 7cm

fig.7

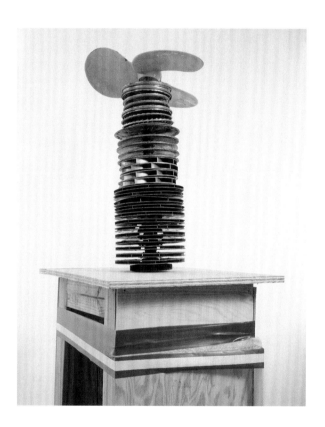

Isa Genzken, *Fuck the Bauhaus #6* (detail), 2000, plywood, metal, plastic, tape, 195 × 70 × 50cm

fig.8

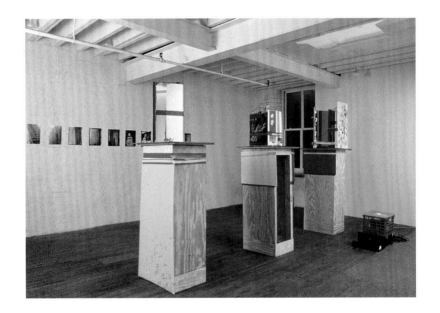

Installation view, 'Isa Genzken: Fuck the Bauhaus (New Buildings for New York)',
AC Project Room, New York, 2000

fig.9

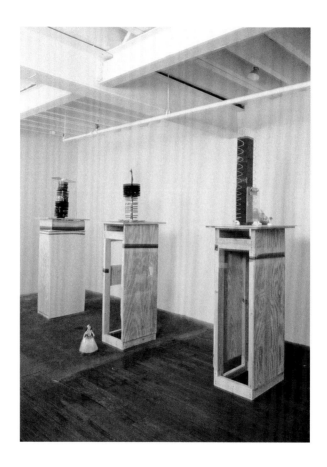

Installation view, 'Isa Genzken: Fuck the Bauhaus (New Buildings for New York)',
AC Project Room, New York, 2000

succumbed 'to the totalitarian order of objects', now all equivalent and exchangeable under the reign of consumption's incessant terror, which voids sculpture of all criteria of selection and judgment and 'brings the sculptor to the brink of psychosis'.[13] Sculpture besides itself.

In contrast to previous readings, the present book pays close attention to *Fuck the Bauhaus* with the aim of elucidating the complexities and nuances of the often observed, yet little appreciated, passage in Genzken's work from architectural fragments to assembled figments. It does so by, on the one hand, situating the series within the artist's prolific experimentations with the architectural model in sculpture from the early 1980s to the late 2000s, including its precursors and later repercussions on the work of other artists. On the other hand, it seeks to concomitantly ponder and reflect on the discourses and doings of assemblage in its wider theoretical formulations and implications — within and beyond the frame and terminology of art history as a discipline. More precisely, this study offers and corroborates a theoretical speculation based on the assumption that Genzken's dynamic mode of fitting and fixing — even though it is undoubtedly informed and influenced by major paradigms in twentieth-century art — might also be analytically approximated through the dispersed (rather than full-fledged) theories of assemblage in post-humanist philosophies, sociology, science and technology studies, as formulated, most notably, in the writings of Gilles Deleuze and Félix Guattari, and Bruno Latour.[14]

Yet, an etymological clarification is needed. Genzken's sculptures, made from a myriad of materials, are better conceived of as *agencements* rather than assemblages. Whereas in the etymology of the English word *assemblage* the stress falls on the joining of things to form a (new) union, the etymology of the French *agencer* (despite its translation as 'to assemble') emphasises the general logic of piecing together and laying out elements. In their reshuffled configuration, these elements are related so as to engender sense and relevance, yet they do remain distinct.[15] In this sense, assemblage is less about fusion than about filiation of its heterogenous parts. Analogously, in Genzken's works of the last two decades, spanning from the advent of *Fuck the Bauhaus* to the series of outfitted and assembled shop mannequins titled *Schauspieler* (*Actors*, begun 2013), the combined components do not attain

meaning by way of being integrated or even sublated into an organic whole, no matter how unusual and perplexing that may appear. Quite the contrary, they retain a sense of displacement and exteriority. Unpacking Genzken's provocative postures and procedures, therefore, entails an insistence on the differences rather than continuities these sculptures entertain *vis-à-vis* the legacies and vocabularies of avant-garde practices, narratives and theories.

Writing about Genzken's assemblages after the year 2000, art historian Yve-Alain Bois has partly sided with the opposite trajectory by emphasising their connections with past art movements. His analysis characterises the artist as a rag picker in the Baudelairean-Benjaminian tradition, and as 'a voracious consumer, but one who is at war with the merchandise: all she buys [...] she immediately declares as trash'.[16] These moments of ostentatious vandalism are discernible in the sculptural gestures Bois refers to in this particular passage, such as, for example, the almost violent juxtaposition and treatment of commodities like toys, vases, fake flowers, suitcases, posters and stuffed animals covered with spilled or sprayed paint in *Empire/Vampire, Who Kills Death* (2003) and *Oil* (at the German Pavilion of the 2007 Venice Biennale). And yet, Genzken's overall assemblage aesthetics hardly qualifies as still partaking in, or even attempting to prolong, the tactics of estrangement underlying appropriations of readymades, concomitant concepts of (photo)montage and *papiers collés* from almost a hundred years ago. Genzken's sculptures are edifices, the elements of which do register — as Peter Bürger's influential 1974 book *Theory of the Avant-Garde* puts it — as material torn 'out of the life totality' and then isolated and fragmented to ultimately create a work that 'proclaims itself an artificial construct, an artifact'.[17] And yet, *Fuck the Bauhaus* and other assemblages by Genzken go far beyond the long-conventionalised routines of the anti-aesthetic effects of montage. These structures do not — as Bürger could still argue for Cubist collages and Dada assemblages — traffic in the 'enigmatic quality of the forms, their resistance to the attempt to wrest meaning from them'.[18]

Contemporary assemblages — or better, *agencements* — as pioneered and manifested in Genzken's recent artistic practice, no longer synthesise 'actual fragments ... of empirical reality'[19] to portray the disintegration of both aesthetic semblance and social unity, so that the 'refusal to provide meaning

is experienced as shock by the recipient'.[20] Although they exude a penchant for the incommensurability of their heterogeneous elements as well as for the decorative excess potentially derived from contrasts and ruptures, all of their components are employed and arranged following the principles of recognisability, legibility and function within a novel configuration that charges them with new semantics and meaning. In this respect, Bois, despite the overt avant-garde leanings of his reading, draws attention (perhaps in a contradictory manner) to the high-spirited, and even encouraging, nature of Genzken's architectural models due to 'their perfect pitch in scale'. Everything, he admits, 'is perfectly plausible in this Lilliputian universe, perfectly adapted to its logic'.[21] Scale consistency is, for Bois, also behind the success of the series *Fuck the Bauhaus*, in which 'none of the objects are brought in to be wrecked but instead function as elements of flamboyant structures'.[22]

It is my contention that this method of fitting and fixing, of filiation and formation, should be described as a disidentification of avant-garde montage from itself and as the inauguration of another aesthetics of assemblage — one that is hardly definable as a 'destruction of the organic work' at war with its materials.[23] It would be myopic to claim that Genzken, in her recent work, engages in a wilful submission of sculpture to the regime of commodity production and consumption. Rather, in its most compelling instances, such as *Fuck the Bauhaus*, her practice articulates a dialectic between the inevitable transformation of sculpture through, on the one hand, the incessant circulation and proliferation of merchandise and goods, and, on the other hand, the possibilities to register or even contest this very regime of object relations within the structure, presentation and dissemination of assemblages promising perceptive, cognitive, mnemonic and epistemic complexity. Instead of just undoing sculpture in a nihilistic endgame of hitherto supposedly binding conventions and values, Genzken's recent works may be said, as philosopher and critic Juliane Rebentisch has argued, to elicit moments and monuments of beauty (not of shock) precisely on the grounds of the decrepitude and debasement of the appropriated and assembled objects.[24] To further develop and substantiate this line of thought, it is necessary to more fully recast the understanding of assemblage in contemporary art towards the notion of *agencement*, as introduced above.

The following notes on Genzken's *Fuck the Bauhaus* are divided into three parts. The first will chart the artist's initial and almost *informe* engagements in the early 1980s, with the architectural model and its capacities to evoke the built environment. These will be comparatively gauged against the reception horizon of the Kunstakademie Düsseldorf (Düsseldorf Art Academy) — in dialogue, most notably, with artists such as Ulrich Rückriem, Thomas Schütte and the towering figure of Joseph Beuys — and within the broader context of reconstruction culture in West Germany. By discussing, amongst other things, Genzken's use of cement and concrete slabs stacked to create models for buildings resembling both ruins and building shells, the (dis)continuities with her later assemblages will be thrown into vibrant relief. The second chapter will trace the artist's increasingly experimental approach and her turn to a different sculptural episteme from the mid-1990s onwards, as manifested in the emerging suture and amalgamation of architectural morphologies with fragments and objects of consumerism, media and technology. Special attention will be paid to the three-volume artist book *I Love New York, Crazy City* (1995–96) that in many ways anticipated and laid the foundation for *Fuck the Bauhaus*.[25] These considerations will be further elaborated with regards to Genzken's later, fully developed methodology of composing and combining readymades in *agencements* that, *pace* dominant art historical interpretations, do not revel in idea(l)s of transgression, but reimagine social interrelations and contemporary (artistic and aesthetic) subjectivity in flux. The third and last chapter turns to *Ground Zero* (2008, fig.28–30), a series that makes earnest, though absurdist, proposals for how to rebuild Lower Manhattan after 9/11. Beyond the vicissitudes of biography and personal expression, the formal laws of Genzken's practice of *agencement*, in which an overabundance of materials coincides with, or even presupposes, the splintering off and abandoning of established conventions and routines (even in works that could be considered 'self-portraits'), will be analysed through the concept of 'late style', as introduced by philosopher Theodor W. Adorno. The book concludes by considering the artist's series of architectural models titled *New Buildings for Berlin* (2001–04, fig.31, 32) in order to reflect, briefly, on the broader implications of Genzken's work for the theory and periodisation

of contemporary art. Elegant vertical structures made of colourful glass shards, *New Buildings for Berlin* appear as perfect counterparts to *Fuck the Bauhaus*. In their own distinct ways, both present the palpable results of a serious and committed, yet ludic and ironic, artistic reshuffling of the world of objects into alternative models for building, dwelling, thinking and living.

THE MODEL AS METHOD:
BEFORE *FUCK THE BAUHAUS*

In her recent ruminations on Isa Genzken's career, feminist art historian Griselda Pollock argues that despite the 'amazing inventiveness' of her practice from the beginning, it has been firmly grounded in a 'Manhattanizing ... of European cities'.[26] Faced with the series *Fuck the Bauhaus* — or others before it, such as Genzken's upright concrete spatial constructions, and yet others in its wake, including *Ground Zero* — it may indeed be tempting to regard the vertical orientation and strict geometry of the modern American cityscape as the ultimate matrix for the sculptor's architectural imagination and, in Pollock's words, as the 'foundation for ... an aesthetic consistency across her work'.[27] In this sense, *Fuck the Bauhaus #6* could well be regarded as a veritable monument to 'Manhattanizing' — the metal propeller stuck on a column made of various discs epitomising verticality to the degree that the construction both figuratively and literally appears to take off from its base. Yet, a closer look at the materials, metaphors and typologies at play in Genzken's first models of buildings, produced in the early 1980s, seems to suggest otherwise.

Invariably modest in size, scale and structure — but not in ambition, as is always the case with Genzken — these designs were created in the context of the Düsseldorf Art Academy or, after her move to Cologne in late 1983 with her then husband Gerhard Richter, in close vicinity to the school, where she was a student between 1973 and 1977. They display a profound entrenchment in the challenging conditions of West Germany's late reconstruction culture and the concomitant ruination and fragmentation of the urban sphere after the Second World War; that is, in the still palpable and lingering aftermath of the atrocities and devastations caused by Nazi fascism. Arguably, concerns for locality inform these works more than the universal aspirations of a generic international style dominated by innovations and inventions issued from the other side of the ocean, no matter how prominent and present they evidently were for Genzken or anyone else living at the outer frontline of the Cold War at the time. By the same token, these sculptural models not only attest to their contemporaneity and geo-political situatedness, they also hark back — as *Fuck the Bauhaus* would do even more explicitly and critically twenty years later — to the aesthetic and discursive formations of Weimar culture in the 1920s, at a time when it was not yet widely recognised as a relevant and valuable cultural heritage.

Hence, these early works share with the later, more prominent series the impulse to both incorporate and emphasise the fissures and fractures of the artist's everyday urban surroundings and to align themselves with art historical precursors, even if comparatively remote or hard to decipher. Rather than paying tribute to Manhattan, Genzken's sombre yet buoyant works from the period may be more aptly characterised as exercises in what architectural historian Kenneth Frampton has called 'critical regionalism'.[28] Writing in 1983, the same year that Genzken started producing her models, Frampton defined 'critical regionalism' as an approach to modern architecture that would be able to mediate between global and local idioms by rejecting both the proclaimed universalism of the International Style and the ornamentality of postmodernism in favour of an emphasis on geographical and cultural contexts.

For sure, at the start of her practice in the early to mid-1970s, Genzken had been largely influenced by, as Pollock states, North American discourses and debates around the spatial expansion and phenomenological address of abstraction and its procedures. Starting in late 1967, right after the premiere of Art Cologne, the first international fair of modern and contemporary art in the neighbouring city, Konrad Fischer Galerie in Düsseldorf presented to largely European audiences a roster of (exclusively male) artists associated with (post-)Minimalism and Conceptualism, amongst them Carl Andre, Dan Flavin, Sol LeWitt and Bruce Nauman. This extensive showcase contributed to the emerging transatlantic outlook of the German contemporary art scene shared by Genzken, her elder colleague Blinky Palermo and others. It was at Konrad Fischer in 1976 that Genzken's first-ever solo exhibition took place, and it featured geometric drawings (*Parallelogramme*, 1975) as well as a projection of a life-sized outline for one of her *Ellipsoids*. The latter are horizontal sculptures made of lacquered wood, and their complex multicolour forms are based on the principle of conic sections. Their intricate twists prompt viewers to gauge spatial intervals and chromatic variations. As critic Birgit Pelzer has elaborated, these works subtly distance themselves from Minimalist literalness by triggering a virtual vortex of perception. In looking at the *Ellipsoids*, the distinction between plane and volume, extension and void, line and shape does indeed become unstable.[29] On the one hand,

these axiomatic structures could be said to intensify and reroute the analytics of space, time and spectatorship articulated in North American art. Planned through a plotter and the protocols of algorithmic calculation, they defy ideas of procreative masculinist technical execution in sculpture; their ornamental colour schemes and curved morphologies further distance them from the ethos of industry informing much (post-)Minimalist work of the time. On the other hand, they still emphasise and identify with, in the words of Buchloh, 'the techno-scientific paradigm underlying most of modernist sculpture in the constructivist tradition'.[30] They are, in Frampton's terms, still invested in the 'optimization of advanced technology'.[31]

However, when Genzken quite abruptly decided, in 1983, to begin modelling sculptures manually in clay and, starting the year after, in plaster, paper, cloth and metal, these aesthetic, theoretical and geo-political alliances figuratively and literally started to crumble — sporadic recoveries notwithstanding. They gave way to *modi operandi* and appearances far removed from Manhattan (as a place, reference or even idea). A new strategy started to inform Genzken's sculptural production that, in Frampton's coinage, seemed 'to mediate the impact of universal civilization with elements derived *indirectly* from the particularities of a particular place'.[32] By the same token, the laborious and lengthy planning and production processes of the *Ellipsoids* and *Hyperbolos* were supplanted by comparatively rapid acts of carving and casting quick-drying materials by hand.

After having grounded her sculptures in actual building sites, from 1983 Genzken gradually turned towards making her incipient architectural models, nine of which have survived from the period. With hindsight, these shapes of projected dwellings register as attempts to dialectically fathom and possibly resuscitate, at least partially, then fairly forlorn avant-garde hopes and promises under radically different sociopolitical circumstances. The construction *Kurtchen* (1984), for instance, made of plaster shaped like the negative cast of a brain and mounted on an upright steel rod, alludes both to a frail human figure and an urban environment under reconstruction. Titled after the diminutive of Kurt Schwitters's first name, this work, now lost, reveals the indebtedness of Genzken's early sculptures to the legacy of German modern art. It clearly pays homage, as all her early models do,

to Schwitters's endeavour to imagine and implement spaces of respite and retreat amidst the chaotic onslaught of consumer and commodity culture, as epitomised in his *Merzbau* (1923–33, destroyed 1943). Immersed in the specific conditions of their making, these experiments create and conjure volatile but inhabitable situations of shelter, sojourn and stay in the medium of sculpture. As such, they detect and render palpable the dereliction underlying, perhaps even haunting, the often hastily rebuilt cities of her home country. In other words, they still belong to post-War art.

In the urban architecture of West Germany (and West Berlin), as Buchloh has observed, the 'remnants of … self-destruction' coexisted with 'Brutalist and hastily inflicted attempts to present [the city] as a new concrete metropolis distanced from the horrors of the recent past'.[33] Evoking the complexities of (post)modern architecture, Genzken's models could be said to gauge the detournement, perhaps even downfall, of the historical Bauhaus vision to create affordable yet generous structures of mass housing based on abstract modular principles. Developers of the 'economic miracle' in the Federal Republic of Germany (FRG) had turned the once utopian and much touted unity of art and technology into the pervasive new reality of interchangeable, corporate façades and satellite cities filled with rows and blocks of anonymous *Neubauten* (new buildings).

Along similar lines, in his 1983 essay Frampton argues that the movements of the 1920s (such as the Bauhaus) 'are the last occasion on which radical avant-gardism is able to identify itself wholeheartedly with the process of modernization'.[34] In the post-War period, however, 'avant-gardism can no longer be sustained as a liberative movement, in part because its initial utopian promise has been overrun by the internal rationality of instrumental reason'.[35] For Frampton, however, a resistant potential lies in a site-related 'place-form' and the dense objecthood of a topographic, tactile and tectonic engagement.[36] Conceived in the expanded medium of sculpture, Genzken's own architectural vision arguably approximates such a critical approach to buildings' situatedness. Time and again her work has fathomed and occupied the clearances entailed within the condensed cartographies of what is left behind by the alienating innovations of capitalism, devastations of historical catastrophe and failures of avant-garde reason.

Therefore, despite the formal, material, referential and contextual differences that separate her early works from *Fuck the Bauhaus*, both present and elicit a space of manoeuvre within the deterioration, even dumpiness, of the built environment that has come to engulf and entrap contemporary subjectivity. Rather than a shared repertoire of obvious motifs, it is because of this consistency in motivation across a gap of two decades that a more comprehensive discussion of the former works and their context becomes necessary to better grasp the meaning and importance of the latter. If Genzken's inaugural dealings with models can be read, as I argue, in terms of a 'critical regionalism' — which, in the German context, was profoundly marked by the legacy of the Bauhaus and Walter Gropius — this category may equally apply to a number of simultaneous artistic practices in the Rhineland region. Just like Genzken, many of her contemporaries and compatriots resorted to scaled representations of architecture in various degrees of decay or decomposition, or as an element of detached decor in the area of exhibition design. As a means of mediating both the locations and forms of architecture, the model allowed them to invoke the mnemonic, at times uncanny, dimensions inscribed into the collective experience of spatial relations in the public sphere of post-War Germany. It also allowed them to probe into the passed-down languages of both gesture and geometry in modernism.

As scholar Sylvia Lavin has emphasised, model-making in the modern era generally 'acquired extra-architectural, instrumental agency when it converged with other technologies in the construction of the so-called public sphere. [...] Along with an emerging complex of newly spatializing communication media [...], architectural models carved out discrete areas from the surface of the earth and presented them as isomorphic with the world itself.'[37] In the hands of artists, the cultural technique of creating models was far less constrained by the demands of similarity and operationalisability central to the rationales of planning processes. It rather assumed another epistemic dimension, more inclined towards spatial poetics and politics. In West Germany, a group of young artists commonly referred to as Düsseldorfer Modellbauer (Düsseldorf model makers), though hardly forming a movement, started mobilising models partly influenced by the precedents

of contemporaries such as Dan Graham, Bruce Nauman and Claes Oldenburg. Despite their variegated approaches, as art historian Stefan Vervoort has argued in his comprehensive monograph on the subject, each of them valued the models 'for the epistemological effects issued by miniaturization and scalar play, for their relation to architecture as a signifier of the social and public realm, and for their association with the private, memory, interiority and the mind, all at the same time'.[38]

It has been repeatedly noted in the critical literature on Genzken that her *Müllberg* (*Pile of Rubbish*, fig.10), from 1984, poignantly marks the turning point from her intricate experiments with Minimalist objecthood and spectatorship to the rough, cracked and chapped constructions of architectural space that would preoccupy her for the coming decade — a transition that, in hindsight, could be compared to the one performed around the year 2000 with the exhibition of the *Fuck the Bauhaus* sculptures.[39] As artist and writer Jutta Koether has stated: 'Something turns in 1984. [...] That which initially seemed highly reflective and sensible and responsive to the history of Modernism no longer functions.'[40] The chromatic and sensuous surfaces of elongated bodies placed on the floor of the *Ellipsoids* are superseded by a heap of debris mounted on a tabletop in the studio (or, in later exhibitions of this and related pieces, on a pedestal). *Müllberg* is mostly made up of plaster, in which bits of yellow and brownish paper are embedded together with metal shards; while splinters protrude from its sides, pieces of burlap fraying at the edges sprout through hardened, polished plaster chunks. Yet the monochromatic accretion of matter and materials, *pace* its pejorative title, does not constitute a mere pile but rather forms an open alcove. Through three tunnels, the viewer can glimpse into a vacated interior space. *Müllberg* clearly registers as a ruin, albeit one 'in reverse', as Robert Smithson would have said.[41] As such, it does not solely document or mourn destruction, but rather plots a place of potentiality. Koether associates *Müllberg* with 'an open image [...], a basic structure that can unfold freely. [...] For the artist this means: seeking the social, having no doors shut [...], accepting that a crash is also possible, giving complex answers. *Owning your bareness.*'[42] Permeable and yet partially protected, this grotto-like refuge has been wrested from the rubbles and residues of everyday experience. It seems

to anticipate *Fuck the Bauhaus #3*'s space of withdrawal, with its courtyard obtained in the void that results from the perpendicular arrangement of metal foil pieces and plastic bars at right angles, and, in its evocation of a grotto, its use of oyster shells adorning both inner and outer walls.

Data, also from 1984, but only made public in 2017, is even more articulate in fusing, as Koether ponders, the metaphor of 'an emotional resource' with 'a model sketching out an idea for a public call for proposals for a redesign of Cologne's Neumarkt square'.[43] Assembled from all (or the little) that was given (hence, one could argue, the learned Latin title), *Data* consists of a structure made of plaster, wire, wood and jute, symmetrically divided into two parts. While one part comprises a mere metal bow, it is complemented in the other part by a modernist curved roof. The open space delineated by the roof is furnished with two wooden miniature chairs that help estimate the scale and intended function of the architecture. Although absent, the human figure is still central to orient the dimension and purposefulness of the construction: a waiting hall designed as a generative and generous space.

In a recently found drawing from the time, presumably commissioned from an architectural office and subsequently amended by the artist, *Data* is physically imagined at a scale of 1:1 (fig.11). The rendering, which does not include the metal bow, places the structure on the geometrically patterned pavement of a plaza in an unspecified urban space. A male figure with his back turned to the viewer stretches towards the ceiling, thus conveying a sense of the open structure's size. In this sketch, marked by the difference between the *informe* density and roughness of Genzken's rugged pavilion and the regular, repetitive and controlled lines on the ground, sculpture veritably does model the space it occupies. The makeshift model — both in its objective reality and as commissioned urbanist rendition — seems again dialectically suspended between the poles of ruination and resuscitation, anticipating the logic at play, albeit in much more flamboyant, flippant and fun form, in the *Fuck the Bauhaus* series.

When Genzken created her first models in 1983, fellow Düsseldorf Art Academy student Thomas Schütte had already begun to experiment with models as one of the primary sites and sources of his sculptural practice. While Genzken's work would eventually lead her to devise a new method

of readymade assemblage, Schütte's artistic trajectory simultaneously reinstated and undermined classical skills, monumental scale and traditional materials in an ironic return to the — however distorted and caricatured — human figure and physiognomy. Faced with the *doxa* of the negation and withdrawal of visuality rampant at the Academy under the influence of Conceptualism, Schütte (who studied in the classes of Gerhard Richter and Benjamin H.D. Buchloh, amongst others) defiantly based his earliest works on a dialectic of decoration and demarcation. Using marginal architectural fixtures such as wallpaper, friezes and garlands, he altered the margins of mundane spaces and passageways. The poles of abstraction and ornamentality are uneasily joined in these sardonic yet laconic and unassuming installations; high art's critical, or even transgressive, aspirations are programmatically undercut with recourse to the banality of pedestrian, petit bourgeois design. Art historian Christine Mehring characterises the artist's approach of the period as follows:

> *If Schütte seizes the space between world history and banality, between idealism and resignation, between public and private, that recourse to a disarming modesty, as it may be called, more often than not takes the form of a highly ambivalent use of design: somewhat functional and somewhat pointless, somewhat engaged and somewhat evasive, somewhat communal and somewhat intimate.*[44]

This reading seems apt not only to Schütte's wall pieces but pertinent to his models.

When, in 1980, curators Kasper König and Laszlo Glozer invited Schütte to contribute to the large-scale exhibition 'Westkunst. Zeitgenössische Kunst seit 1939' ('Art of the West: Contemporary art since 1939'), slated to open at the Messehalle in Cologne the following year, the artist conceived a series of three painted-wood models of scenographic devices or situations. Documented in photographs by Candida Höfer, another student at the Academy, one of these works, *Bühne (Modell 1:20) (Stage (Model 1:20)*, 1980, fig.12), presented viewers with a miniature oval-shaped stage, elevated over three greyish steps of stairs and encased by a curved golden-yellow wall with

a black verso and two red pilasters on each side. Sporting the colours of the national flag of the FDR (black, red, gold), the colour scheme of *Bühne* does not signal the artist's aspirations to represent the nation-state as its official artist. On the contrary, it deflates the desire for grandeur by recoding the elements of the flag as merely decorative monochrome sections. At a scale of 1:20, the stage serves to display small-format lacquered images enigmatically showing the letter *H* in several variations of hue and typography — a motif previously used in Schütte's multipart work on paper *Hysterie* (*Hysteria*, 1979). Two figures (a man and a woman) are installed within this open exhibition pavilion. Acting as museum visitors, they perform under the gaze of other visitors, in a dizzying mirror effect. In an alternative version (with the same title and from the same year), the stage remains empty except for a large blue curtain thrown over the wall and partly concealing the backdrop of the vacated scene.

For the exhibition 'Westkunst', Schütte produced two other models: *Schiff (Modell 1:20)* (*Ship (Model 1:20)*, 1980), a ship with a garland of pennants on the bow and rows of vibrant geometrical banderols along its sides; and *Kiste (Modell 1:20)* (*Box (Model 1:20)*, 1980), a coffin-like monument consisting of a brown box made of wood and elevated on one side by three metal columns. Often read as critical *mises en abymes* of the contemporary exhibition dispositive, the ship, funerary monument and stage, Vervoort has suggested, represent respectively three positions in twentieth-century art, namely 'the hope and progress associated with modernism, the defeatism and stasis tied to anti-modernism, and the stage as a site of fiction'.[45] In this reading, Schütte's recourse to the architectural model serves to conceptualise his own art in the aftermath of both the symbolic languages of commemoration in public sculpture and the avant-garde's infatuation with technology. By literally setting up a stage, the artist opens the way for a return of narrative, figuration and play — an aperture to postmodernism.

Despite her expressed wishes, Genzken was not included in the exhibition 'Westkunst'. However, she must have been aware of Schütte's maquettes; to a certain degree, they informed the models she made a few years after. Her sculpture *Bahnhof* (*Station*, 1984, fig.13), for instance, demonstrates her quest for spaces of respite and relief built on the rubbles

of failed ambition and unattained utopia. Looking at this model, it is hard to determine whether its architecture is about to be torn down or built up. Under a concave, roof-like fragment made of plaster — the signs of the casting process still visible in the rectilinear lines streaking the interior — a negative space emerges. Providing both protection and room for communality, the structure hosts three miniature figures (two male, one female) who — as the scenario suggested in the title implies — are waiting to leave for elsewhere. Their position appears as provisional as the site where they are temporarily gathered. Compared to Schütte's parodistic approach, Genzken's models from the early 1980s seem more subdued and inconclusive. Nonetheless, they do share an interest in the inherent or incidental theatricality of the everyday as a possibility to exceed the given apparatus of architecture and the protocols it both imposes and enables.

Roughly half a decade later, this dimension would return amplified in *Fuck the Bauhaus #4*, with the artist explicitly proposing, it would seem, a new scheme for the stretch of Broadway that runs through Lower Manhattan. Alongside a silver-coloured lightshade decorated with bright-pink petals, which presumably mimics a (movie) dome, this assemblage consists, for the most part, of a transparent red plexiglass container standing upright. Functioning as the main tower of a skyscraper, it is adorned by a drooping yellow Slinky and surrounded by shells that appear to serve as stand-ins for abstract public sculptures. Attached to it as a low-rise extension is a clear yellow clipboard that holds, on one side, a cut-out from the monthly theatre bulletin *Playbill*, and, on the other, a black-and-white photograph of an empty stage with a spotlight directed at the closed curtain — as if an incipient play is about to be performed for passers-by on the plaza, circumscribed by the skyscraper and dome at the centre of the plywood pedestal. Here, in Genzken's hands, the cityscape becomes an expanded theatre stage, much like the gallery became a *Bühne* in Schütte's model vision.

In 1986, after a relatively brief period, yet another turn can be mapped onto Genzken's practice, as is often remarked in the critical literature on her work. Leaving behind the more expressive medium of plaster models, with their variegated surfaces, unexpected proliferations of plasticity and subtle chromatic values, the artist started working almost exclusively with concrete

and cement. Architecture remained her primary sculptural preoccupation; however, the aspects of manual labour and execution became almost untraceable in these new models, which increasingly assumed the character of 'anonymous sculptures', to borrow the title of Bernd and Hilla Becher's famous 1970 book of photographs typologically documenting industrial infrastructures at the brink of obsolescence and disappearance.[46] Innately crude, brittle and grey, concrete is a hard-to-handle material grade that eschews artistic control. Depressions, indices and air pockets determine the look of strata and segments in unpredictable ways. The gradations and streaks of hues — located on the restrained chromatic spectrum of ash, lead and silver, interspersed with tints of white or light blue — result from the contingencies of pouring concrete into moulds. The material's innate properties ultimately resist further design decisions. Genzken created special moulds in wood or Styrofoam and, after the curing process, stuck together concrete sections and blocks to form more or less identifiable architectural morphologies with titles such as *Tür* (*Door*), *Zimmer* (*Room*), *Kirche* (*Church*) and *Bühne* (*Stage*).

In a conversation following her participation, in 1987, in the second iteration of Skulptur Projekte Münster — for which she contributed *ABC*, a double gateway fabricated in metal and concrete, demarcating a passageway on a plateau of a recently opened university library — Genzken stressed a newly developed interest in the 'machine-like' appearance of her models.[47] To a certain degree, in these works the model as a category becomes a paradox, since it is bereft of its quality to articulate mutability and, therefore, futurity. Figures and details are absent. The very notion of the model seems to shift, one might argue, from metaphor to metonymy. As Buchloh has written, Genzken's use of concrete 'does not allow for an infinite variation of textures and surface effects in the way that plaster would have suggested, neither does it allow for the seductive historical associations with architecture models'.[48] Yet, Genzken's concrete sculptures approximate more closely than their immediate plaster precursors the base materialism of building blocks. They register as fragments rather than three-dimensional sketches. While the inherently preliminary material of plaster always implies an anticipatory study, the later aggregations of slabs forming roofless

fig.10

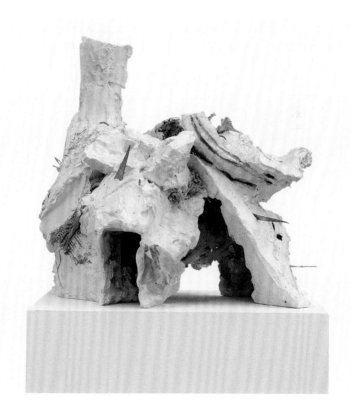

Isa Genzken, *Müllberg*, 1984, plaster, metal, paper, cloth, 42 × 42 × 47cm

fig.11

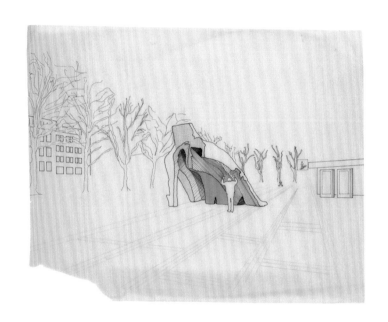

Isa Genzken, Untitled, ca. 1984, ink and pencil on transparent paper, 33.5×42cm

fig.12

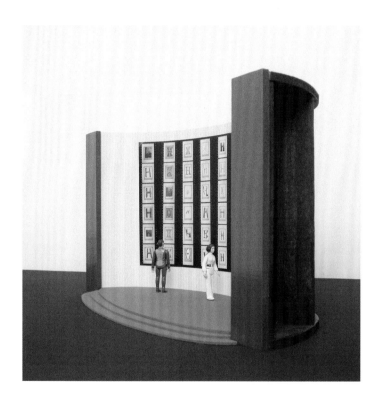

Thomas Schütte, *Bühne (Modell 1:20)*, 1980, wood, paint, photographs, 35 × 50 × 25cm © DACS 2023.
Photo: Candida Höfer © Candida Höfer/VG Bild-Kunst, Bonn and DACS, London, 2023

fig.13

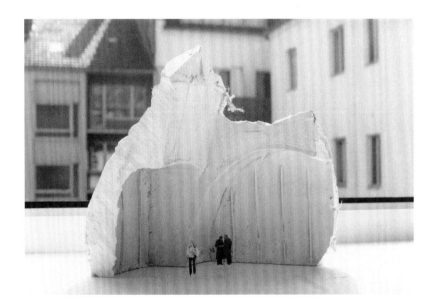

Isa Genzken, *Bahnhof*, 1984, plaster, paper, 26 × 23 × 25cm

fig.14

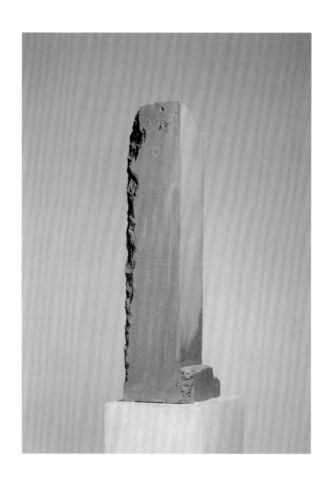

Isa Genzken, *Hochhaus*, 1986, concrete, steel, 88 × 25 × 22cm

fig.15

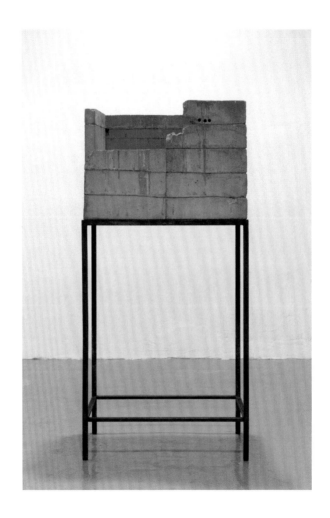

Isa Genzken, *Halle*, 1987, concrete, steel, 202.7 × 97 × 62cm

fig.16

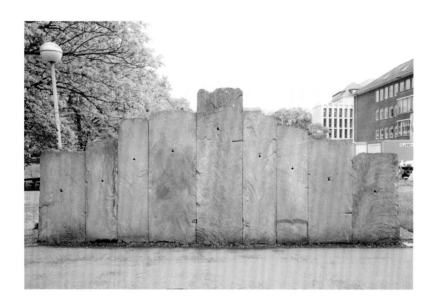

Ulrich Rückriem, *Dolomit zugeschnitten*, 1977, nine slabs of dolomite, 330×720×120cm.
Installation view, Skulptur Ausstellung in Münster, 1977 © City of Münster

fig.17

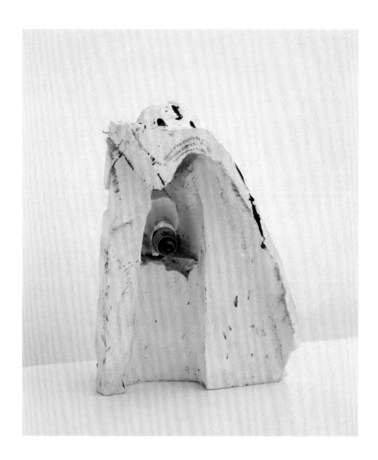

Isa Genzken, *Birne*, 1984, synthetic polymer paint on plaster, light bulb, 30×20×22cm

fig.18

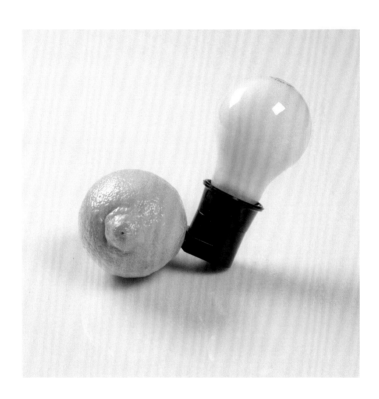

Joseph Beuys, *Capri-Batterie*, 1985, light bulb with plug socket, lemon, screen printed wooden box, offset lithograph, 6.4×11.4×6.4cm. Courtesy the RISD Museum, Providence, RI © DACS 2023

fig.19

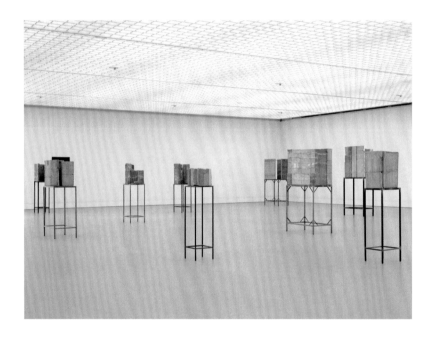

Installation view, 'Isa Genzken: Sculptures 1978–1989',
Museum Boijmans Van Beuningen, Rotterdam, 1989

fig.20

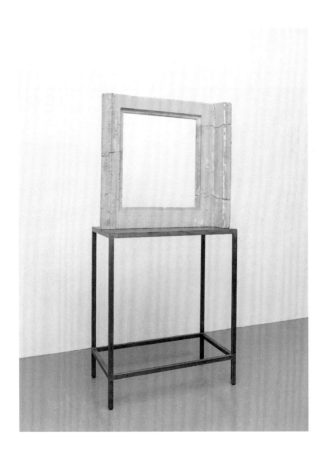

Isa Genzken, *Fenster*, 1990, concrete, steel, 264.5 × 124 × 68cm

fig.21

Isa Genzken, *Venedig*, 1993, epoxy resin, steel, 2 parts, each 350×99×65cm.
Installation view, 45th Venice Biennale, Palazzo Ca' Vendramin-Calergi, Venice

fig.22

Isa Genzken, *I Love New York, Crazy City*, 1995–96, paper, gelatin silver
prints, chromogenic colour prints, tape, 3 artist books, each 39×30.5×7.5cm

fig.23

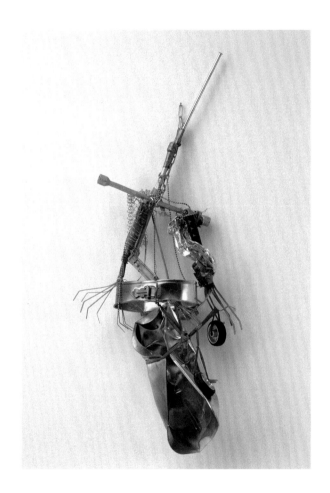

Isa Genzken, *Schwules Baby*, 1997, steel, aluminium, rubber, fabric, 130×60×25cm

fig.24

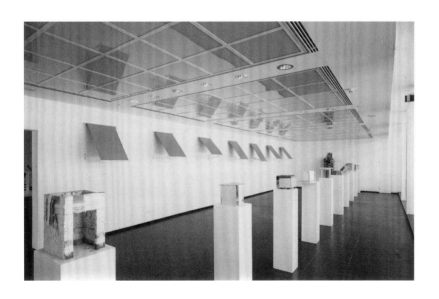

Installation view, 'Isa Genzken: Urlaub',
Frankfurter Kunstverein, Frankfurt, 2000

fig.25

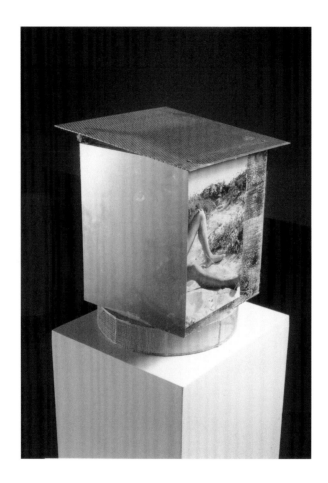

Isa Genzken, *Strandhäuser zum Umziehen*, 2000, metal, wood, paper, seashells, 178×34×35cm.
Collection Frac Grand Large – Hauts-de-France

and open spatial structures pretend to relate as *pars pro toto* to the built environment. The fact that one of the first works from the series was titled *Neubau* (*New Construction*, 1985) is telling in this respect.

Whereas the plaster models display curvatures and irregularities, the artist's concrete constructions stress verticality and right angles, indeed prefiguring a 'Manhattanizing [...] of European cities', to invoke once again Pollock's claim. In spite of evident differences in colour, composition, materiality and appeal, they irrefutably suggest a closer rapport to the assemblages of high-rise constructions in *Fuck the Bauhaus*. However, with respect to the fate and function of modern architecture after the violent annihilation of avant-garde aspirations to reform or even revolutionise conditions of mass living and urban housing, they arguably present two opposite conclusions or strategies. Genzken has remained consistent in her complex (in the etymological sense of the term) critique of the inflictions and indignations of architecture since the heydays of modernity. While the models of *Fuck the Bauhaus* ostentatiously overthrow the strict cubic modularity and functionality of modern architecture by way of an excess and wilful ornamentality of the means and materials employed, Genzken's concrete sculptures both mimic and exacerbate the rigorous geometries, monochromaticity and nondifferentiated use of materials underlying, as Lee has pointed out, the 'unornamental facades' of the 'satellite cities' erected, from the 1960s onwards, after the principles of Neues Bauen (New Objectivity).[49]

Genzken's concrete *Hochhaus* (*High-rise*, 1986, fig.14) is even more provocative in its economy of means — a negative mirror image of the overall abundances of *Fuck the Bauhaus*. One exception, perhaps, is *Fuck the Bauhaus #5*, for which Genzken created an improvised and impoverished tower of metal discs topped with a pole made of red tape, still showing the signs of simplicity and paucity characteristic of the artist's preceding concrete works. The earlier *Hochhaus* is a mere cast pillar of light grey concrete, with a low protrusion resembling a staircase on its side and analogically punctuated by tiny holes in its upper region. Most poignantly, a crack that runs along the entirety of one of its vertical edges increases in intensity towards the slightly oblate top, seemingly eating away at the structure.

Once again, it is impossible to determine if viewers are confronted with an architecture in decay or growth. Does it conjure haunting spectres of destruction, or does it suggest elevation and departure amidst the suffocating strictures of reconstruction culture? This same 'peculiarly temporal dimension'[50] can be discerned in virtually all of Genzken's concrete models of the period, such as *Halle* (*Hall*, 1987, fig.15) and *Durchgang* (*Passageway*, 1987). The former presents an open angulated structure of nested wall sections, each resulting from the horizontal addition of discrete rectangular segments, made evident by uneven cracks and joints. This configuration simultaneously reads as both shelter (or bunker) and construction site.

If Genzken's plaster models were influenced by Schütte's maquettes, her later series of concrete sculptures are clearly informed not only by the reduced syntax and ill-fated visions of modern architecture, but also in dialogue with other local artists. Perhaps most pertinent in this regard is the practice of German sculptor Ulrich Rückriem, who, beginning in 1969, shared a studio with Blinky Palermo, Genzken's friend, and taught as a professor at the Düsseldorf Art Academy between 1984 and 1988. Under the influence of Minimalism and Arte Povera, Rückriem's works, often reminiscent of Middle Bronze Age menhirs, consist mainly of stones cut at quarries and meticulously arranged to address the particularities of public sites. For *Dolomit zugeschnitten* (*Cut Dolomite*, 1977, fig.16), for example, Rückriem (re)assembled vertical steles of different heights cut from one block. Installed on the occasion of the first iteration of Skulptur Projekte Münster in 1977 (then called Skulptur Ausstellung in Münster), and on permanent view since 1987, *Cut Dolomite* sits on the pathway of St Petri Church, creating a passageway with its north façade. While the side facing passers-by forms a straight wall, the back slopes towards the ground. What is always on view, however, much like in Genzken's models, are the fissures and slashes involved in creating the object. Despite differences in format, process and material, obvious resemblances connect Genzken's concrete models with Rückriem's practice. Yet their shared aesthetic of an obtuse materiality, laboriously overcome through palpable processes of joining fragments into coherent and logical forms, does not imply a common conception of sculpture *vis-à-vis* architecture. Whereas Rückriem mobilises

a prehistoric language of monumentality to suggest an almost transhistorical *longue durée* of sculpture's presence, each of Genzken's works in concrete interrogates the very temporality of architecture. Time and again, her sculptures, as Buchloh has noted, embody a 'dual nature [...] a negative sculptural model of architectural space as much as a remnant and a ruinous particle of an architecture of the (recent) past'.[51]

This temporal suspension between the poles of a dystopian history and an utopian time to come is amplified by the specific presentation of the works on metal pedestals that place them at eye level, as evidenced in installation shots from the exhibition 'Isa Genzken: Sculptures 1978–1989', on view at the Museum Boijmans Van Beuningen in Rotterdam in 1989 (fig.19). An integral part of all her concrete sculptures, these display devices allow for spectatorial engagement with both the carefully calibrated scale of the models and the (only) perceived monumentality they mimic through the proportions of their evacuated expanses. Genzken's pedestals undoubtedly derive from the tables elevating the vitrines that Joseph Beuys, the towering shamanic figure of the Düsseldorf art scene and contemporary German art at large, had started creating in the late 1960s, in the context of his ritualistic and anthroposophical adaptations of post-Minimalist sculpture and Fluxus products, through the use of organic materials like fat, honey, wax, felt and chocolate.[52] Genzken was in touch with Beuys on numerous occasions, both within and beyond the Academy. One of the young artist's last architectural models in plaster, *Birne* (*Pear*, 1984, fig.17), may even have inspired Beuys. For this work, she created a broken alcove and placed a light bulb into a small recess, with the base cap facing the viewer and hence with no chance of performing its function. The year after, Beuys would issue his famous edition *Capri-Batterie* (*Capri Battery*, 1985, fig.18) that, along the lines of his pseudoscientific theories of entangled universal forces, purported to ignite a yellow light bulb with the energy extracted from a lemon of comparable colour, size and shape.

Besides the more or less easily traceable, direct and mutual influence on single pieces and display methods, Beuys made an indelible impact on Genzken, as she attested in a 2006 interview,[53] in his sculptures' capacity to counter and challenge architectural environments as well as branch out

of the self-enclosed impartiality of the modernist object. When Genzken
contributed the installation *Oil* to the German Pavilion at the 2007 Venice
Biennale, she referred to Beuys's *Straßenbahnhaltestelle — Ein Monument
für die Zukunft* (*Tram Stop — Monument to the Future*), made for his solo
exhibition representing West Germany at the 1976 Venice Biennale, as
one of the works produced for the site that she held in higher esteem (while
she quite surprisingly expressed her dislike of Rückriem's participation
in 1978 and Hans Haacke's in 1993).[54] Beuys's installation was based on
a seventeenth-century monument in Cleves, his hometown in the Rhineland
region; the statue, commonly referred to as 'The Iron Man' and originally
erected as a sign of peace, was eventually placed next to a tram stop close
to his childhood home. Beuys produced, amongst other elements, a cast
of a field cannon as well as the four mortars surrounding it. He then drove
a more-than-seven-metre-long pole deep into the ground of the exhibition
hall, a building the Nazis altered and expanded in 1938. The pile of earth and
rubble resulting from this intervention was arranged in a mound next to
the column, the top (or mouth) of which was adorned with an iron sculpture
of a man's head, his face contorted in a grimace of pain or fear. A single
tram rail inserted into the floor completed the installation, which ultimately
obliterated the space of the exhibition in favour of a place devoted to personal
recollection.[55] The intense affect of trauma, loss and memory, as well as the
physiognomic pathos exuding from Beuys's installation, hardly resonate with
Genzken's conceptually and contextually oriented work. Yet, in an evidently
less egomaniacal and gigantic manner, her concrete models equally attempt
to fathom the ramifications of experiencing urban space built in the aftermath
of modernity's destructive effects.

Presenting itself simultaneously, in the guise of a perfectly scaled ruin
and anticipatory sculptural configuration, the model was and would remain
Genzken's preferred method. However, from the mid-1990s, the artist's
aesthetic and epistemic approach to sculpture as both an adversary and
associate of architecture would change once again. She increasingly departed
from post-Minimalist explorations of process and objecthood, and ventured
instead towards experimental procedures of appropriation and assemblage
steeped in, or moored by, what anthropologist Arjun Appadurai defines as

the 'social life of commodities' and the 'politics of diversion and display' it entails and encourages.[56] *Fuck the Bauhaus* would prove to open up this expanded artistic endeavor and, ultimately, epitomise the impact that Genzken's work continues to exert on the theory and practice of contemporary art at large.

ANOTHER ART OF ASSEMBLAGE:
MAKING THINGS (MIS)FIT

Differences in theoretical leanings and methodological orientation
notwithstanding, the many prominent commentators on the art of Isa Genzken
all seem to agree that the markedly heterogeneous phases of her oeuvre are
only held together by the artist's 'courage to enter new uncharted territories,
her affective aversion against the recognizable'.[57] In this sense, Juliane
Rebentisch, in discussing Genzken's 'sense for the historicity of art', points
out that 'little is as repugnant to her as the safety with which others
accommodate themselves in the once successful — as though there were
no history, as though what was once good could be preserved as such without
having to submit, again and again, to renewed critical consideration'.[58]
With hindsight, it seems almost logical that the architecturally-minded
sculptural objects that Genzken conceived and produced for almost a decade,
would, by the end of the 1980s, begin not only to assume a different form
and materiality, but also to establish new relationships with their place
of installation. While her previous plaster and concrete models purported
to supersede, at a reduced scale, the built environment with a virtual one,
Genzken's later pieces started instead to literally add architectural components
to it. If the former works presented a new vision of urban planning — albeit
one temporally suspended between the poles of construction and ruination
— the latter brought architectural details to spectatorial attention and
consideration. In the suite of works titled *Fenster* (*Window*, begun 1990, fig.20),
for instance, the artist offers exposed fragments of architecture in the shape
of open apertures at a scale of 1:1. For the most part still mounted — with the
help of Beuysian display devices — these pieces are installed slightly below
eye level so that viewers can look through them.

Considering this series, a shift in Genzken's materials is discernible
from the works executed in dull concrete, as in the first *Fenster*, to the bright-
yellow epoxy resin mostly used in the pieces made from 1992 onwards.
By opting for translucent materials, Genzken was able to make visible the
internal steel armatures used for casting these shapes. These sculptures
no longer project space, but, as site-specific interventions, all 'frame their
respective environments'.[59] *Venedig* (*Venice*, 1993, fig.21), for instance, consists
of a pair of empty window frames, each divided by two shutters connected
by hinges and made of yellow and, in the top sections, blue epoxy resin. As a

relatively tall sculpture installed in a gallery (or palazzo), *Venice* oscillates between paravent and casement, its diaphanous surfaces actively confounding both the definition and perception of inside and outside. Looking across or through its openings (as well as its see-through shiny contours), the reality of a place or situation is brought into focus in a defamiliarised perspective, which shifts based on the viewer's own subjective position. 'Everybody needs at least one window' was the programmatic title of Genzken's first institutional exhibition in the United States, at the Renaissance Society at the University of Chicago in 1992, which juxtaposed, amongst other works, concrete models with her most recent windows.[60] These particular sculptures certainly attest to, in Rebentisch's words, the 'worldliness of her art'.[61] With the intention of stressing the distance that separates Genzken's entire oeuvre from a modernist aesthetics of autonomy — whose 'worldlessness' derives from the taboo imposed on any referentiality — Rebentisch goes as far as to maintain that 'her art is, in a certain sense, realist: not in the sense of a simple representation of empirical reality, nor even in the general sense in which any art is always itself part of reality. Genzken's art appropriates reality.'[62]

This holds even more true for the artist's later assemblages, of found or purchased readymade objects arranged to seem anomic, yet highly accurate, as first fully manifest in the architectural models of the *Fuck the Bauhaus* series. While Rebentisch's systematic argument is mostly accurate, it tends to level the substantial morphological, material and methodical differences between the distinct bodies of sculptural work constituting Genzken's realism. The artist's assemblages behove a closer look in order to come to terms with the conceptual concerns and aesthetic complexities that mark them out from their precursors within what is a shape-shifting but consistently concise oeuvre. As Rebentisch observes, Genzken's 'materials and elements' are quite evidently 'taken from our everyday lives', but, when incorporated in her assemblages, they 'do not remain [...] what they are outside, available to familiar perception: mere dull things'.[63] How, then, are we to exactly assess, in philosopher (of assemblage as *agencement*) Manuel DeLanda's words, this intricate 'action of matching or fitting together a set of components'? And how are we to analyse the respective 'ensemble of parts that mesh together well' resulting from it?[64]

In his famous 1953 essay 'The World as Object', focussing on Dutch seventeenth-century still lifes, French literary theorist Roland Barthes turned to the concept of assemblage to note that in this genre of painting the world becomes an 'empire of things', leading to 'a "modern" esthetic of silence'.[65] Given that in those paintings all matter — oysters, pottery, metal cups, grape seeds and so forth — is united and coated under a glaze of sheen and viscosity, Barthes's question becomes: 'What can be the justification of such an assemblage if not to lubricate man's gaze amid his domain?'[66] The sculptures in the *Fuck the Bauhaus* series (as well as in subsequent ones by Genzken) hardly employ or revel in a gleam that would bring all of their disparate elements into the coherence of a shared surface. Yet their elements do not appear disparate or even randomly scattered either. By considering the *agencements* developed in Genzken's contemporary sculptures within the *longue durée* of debates on the aesthetics of assemblage since the rise of modernity, this chapter attempts to find divergent 'justifications', or, in the etymological sense of the term (as contemplation or speculation), appropriate *theories* for composing and combining worldly objects that resonate with Genzken's reinvented practice from the mid-1990s onwards.

Genzken's three-part artist's book *I Love New York, Crazy City* (fig.22), both anticipates and prepares, in the medium of collage, many of the themes, motifs and principles of *Fuck the Bauhaus*, produced only a few years later in the same city. On each spread of this 'scrapbook' — both a visual diary of an extended New York stay by the artist and a derailed travel guide — are Genzken's juxtapositions, often organised in fairly neat lattices, or rows and tiers, of utterly heterogeneous materials. Browsing through its large-format pages, viewers encounter advertisements and articles torn out of magazines, concert tickets, photographic self-portraits, snapshots of others, snippets of shopping bags, hotel bills, ATM receipts, faxes, calendar pages, business cards, stickers, menus, napkins and price tags, as well as pictures of indistinct interiors, high-rise buildings and mirroring façades (some of which would later adorn the walls of AC Project Room in Chelsea in the 'Fuck the Bauhaus' exhibition). Speaking to critic Diedrich Diederichsen about the time and context in which the book was made, Genzken explained:

I wanted to move to New York. In the beginning I didn't have a studio and lived in a hotel, so I took pictures. [...] And at some point I put them together and pasted them into books. The idea was to make a guidebook for New York — not a normal one, but something for people who wanted to experience New York differently for a change: a lot crazier, more special, more multifaceted and beautiful.[67]

As with some of the sections of the *Fuck the Bauhaus* assemblages, this hodgepodge of items and images of empirical urban reality is fixed and held together solely by wide strips of colourful packaging or adhesive tape. In keeping with the usual vertical orientation of a book, or a street map of Manhattan, the bits of tape, which come in various hues and widths, are arranged so as to form a grid structure where collaged sequences unfold in the interstices. When viewed, or rather pieced, together, these stretches generate the fragmented, manifold portrait of a perpetually wandering, even disoriented subject, moving through a global metropolis that appears on the verge of dissolving into the labyrinthine ramifications of commerce and consumption, media and entertainment, architecture and design. In the same conversation with Diederichsen, Genzken compares *I Love New York, Crazy City* to a narrative feature film on the city.[68] As this reference to cinema makes clear, the collages compiled in the book proceed syntactically (be it on singular sheets, double spreads or page sequences). The 'film' of this book is no 'montage of attraction', to evoke Sergei Eisenstein's famous description for an avant-garde aesthetic of shock, interruption and discontinuity.[69] Despite some superimposition, each component of this convoluted structure remains visible or readable. Just as in *Fuck the Bauhaus*, within this puzzling new configuration of pictures, objects and printed matter, each element is connected to the others, while retaining its own referentiality and distinct meaning. Contrary to Rebentisch's generalised contention, a closer look at this kind of assemblage reveals that everyday materials and elements actually do remain what they are outside, even though they surely become, in Genzken's hands, other than dull things.[70]

Keeping with the subject matter of metropolitan life in Manhattan, the accumulation and arrangement of readymades at the core of *Fuck the*

Bauhaus ultimately transfers the logic and practice of such an aggregative — rather than aggressive — collage into the discursive, spatial and aesthetic formation of sculpture. Radically transforming the operations and effects that developed during the heyday of the (neo-)avant-gardes, another art of assemblage emerges — one that differs in making things (mis)fit. Materials are drawn together, but do not merge. A place and a function are assigned to things and images within a new context without defining their identities. In such an assemblage, according to philosopher, anthropologist and sociologist Bruno Latour, 'any given interaction seems to *overflow* with elements which are already in the situation coming from some other *time*, some other *place*, and generated by some other *agency*'.[71]

The earliest series (of altogether three works) amongst Genzken's three-dimensional assemblages, provocatively titled *Schwule Babies* (*Gay Babies*, 1997, fig.23), in retrospect might be seen to epitomise both the flamboyancy and criticality of the works ensuing at the turn of the millennium. Cobbled together entirely from kitchen equipment made of metal, rubber and fabric, and hanging off several hooks on the wall like a relief, one of the loosely configured modest constructions, as curator Laura Hoptman has noted, presents viewers with an anthropomorphic figure resembling a robotic puppet.[72] Pot lids stand in for the head, while baking tins signify the hips and bent whisks the arms and hands. Recalling Man Ray's *La Femme* (1920) — a photographic portrait of a woman as an eggbeater hanging on a wall fixture — this assemblage too implies movement. Man Ray's surrealist *mise-en-scène* was based on an obvious act of gendering his found object by making a domestic appliance recall the reified and sexualised morphology of a female body. Genzken, as the work's queer title suggests, bypasses any binary identification. Not only does her assemblage eschew the sight of a gestalt, but the ambiguous arrangement of its dangling parts, unevenly sprayed with fluorescent blue paint, alludes to an unsexed and proudly exhibited body.

Only a few months prior to the first exhibition of *Fuck the Bauhaus* in New York, in the spring and summer of 2000 Genzken included a series of sculptures called *Strandhäuser zum Umziehen* (*Beach Houses for Changing*, 2000, fig.24) in her exhibition 'Urlaub' ('Holiday') at the Frankfurter

Kunstverein. This set of works arguably marks a pivotal moment in the conceptualisation and production of her later assemblages. Once again, the architectural model serves as the catalyst for a new phase in the artist's oeuvre. As the title indicates, the ten assemblages present designs for beach huts at small scale, and all combine found images and everyday objects within pavilion-like structures, some resting on actual sand. Mirrors, painted pieces of paper, sticks of bamboo, seashells, confetti, metal, plastic film, straw and photographs form individual shacks that seem to offer release and retreat from the frenzy of daily life. Displayed at eye level on a row of white pedestals of the same height, alongside seven bright-orange *Marquees* (2000) installed on the adjacent wall and facing the assisted readymade *Spielautomat* (*Slot Machine*, 2000, fig.26), Genzken's makeshift structures do not engage with the contemporary reality of corporate design, but rather present proposals for temporary bungalows used for leisure activities.

So far, Genzken's *Beach Houses* have received relatively little critical attention. In a rare discussion of them, Yve-Alain Bois defines the works as manifestations of a 'poetic bricolage', stressing 'the deliberate clumsiness of their assembly, the deliberate poverty of the materials, and the lushness of their colors', as well as their evocation of 'the flexibility and necessary lightness of nomadic dwelling'.[73] Indeed, they exude a sense of fragility and precarity with their improvised, dangling rooftops and unstable walls. In some, the façade is simply stacked together and kept erect only by the laws of gravity (perhaps in an ironic tribute to Richard Serra's 1969 *One Ton Prop (House of Cards)*, for which the artist used four heavy sheets of lead antimony, their edges leaning against each other, to intimate the architecture of a cube). Genzken's huts are as permeable as they are permissive. Apertures and pieces of plastic mesh allow for glimpses of their interior. Photographs grace entire exterior and interior walls, and, due to their scale, evoke billboards or wallpaper respectively.[74] While a cropped black-and-white photograph shows the androgynous legs of a sunbathing person as if protruding onto the sandy beach from a cabin, pornographic images attached to the inner walls offer close-up scenes of gay sex (fig.25).

More than just formal and iconographic, these assemblages are decidedly *camp*, in the sense famously elaborated by Susan Sontag in 1964, as 'the

love of the exaggerated, the "off", of things-being-what-they-are-not', and as a taste that 'draws on a mostly unacknowledged truth [...]: the most refined form of sexual attractiveness (as well as the most refined form of sexual pleasure) consists in going against the grain of one's sex.'[75] In spite of the gender essentialism of this passage, Genzken's *Beach Houses for Changing* certainly align themselves with such a sensibility for the artificial and exaggerated. This aspect had already surfaced in the earlier group of fourteen photographic diptychs titled *Liebe als Wesen* (*Love as Being*, 1996), each of which juxtaposes or blends gendered details of same-sex bodies within the boundaries of a composite image, so as to arrive at an array of sexually ambiguous montages.[76] Art critic David Bussel convincingly argues that the *Beach Houses* offer a home to cycles of queer desire by staging thresholds between public and private, voyeurism and exhibitionism, inside and outside.[77] Beyond matters of taste and topic, Rebentisch has also related Genzken's overall sculptural approach of employing found materials, dysfunctional objects and devalued commodities to the notion of camp. As she writes:

> *The sensitive attention to the irreducible traces of humanity at the damaged spots of the discarded fetish corresponds [...] to renewed posture and procedure of critical melancholia: here, she is camp. In Genzken's works, the flip sides of systems of exploitation, the rudiments of failure, the abandoned scenarios of history, promise [...] a different and better life.*[78]

It may be thus argued that such a sculptural poetics of *agencement*, which gives a surprising fillip to the materials and morphologies it (re)arranges, entails a queer politics based precisely on defiantly actualising the dormant or overlooked potential of the derailed and demoded in the name of heretofore unforeseeable futurities. Instead of pursuing the utopian goals encapsulated in avant-garde culture's prevailing negativity, Genzken's assemblages find and offer consolation, jouissance and even hopefulness in the troves and treasures to be found when picking through the remains of consumption and expenditure. Made of tattered things and throwaway

images, the artist's sculptural models for provisional beach huts provide structures for an unburdened subjectivity that defiantly appropriates, freely cruises and joyfully revives the recycled ruins of all that has washed ashore.[79] Their capacity to project such an 'euphoric, so encouraging' site is predicated on the enactment of assemblages that privilege association over dissonance. Here, as in *Fuck the Bauhaus*, all the parts, media and materials used, despite their persisting singularity and distinctness, cohere in and conform to 'the same dollhouse-scale'.[80]

Assemblage evidently is a key term in the lexicon of avant-garde art and its aftermaths. It denotes the appropriation and arrangement of existing and scavenged items and images rather than the Promethean wrestling of objects and morphologies from formless matter. Due to its entanglement with reproduction, repetition and recurrence, in the history of modern(ist) sculpture, including the *doxa* of originality and authenticity, its praxis and principles have often been associated with the feminine — a construction based on a gender binarism that has, nonetheless, allowed for Genzken's critically camp melancholia. Paradoxically, although not surprisingly, this historical qualification did not preclude the establishment of a mostly male canon, which, with the exception of Hannah Höch, goes from Jean Arp, Marcel Duchamp, Max Ernst, Pablo Picasso and Kurt Schwitters to Joseph Cornell, Edward Kienholz, Robert Rauschenberg, Jean Tinguely and Daniel Spoerri. At least this was William C. Seitz's rubric of a major strand of Western art from the first half of the twentieth century right up to the neo-avant-garde period (including Neo-Dada and Nouveaux réalisme) in his landmark exhibition 'The Art of Assemblage' at the Museum of Modern Art (MoMA) in New York in 1961.[81]

Seitz's catalogue essay, 'The Poetry and Realism of Assemblage', clearly influenced by the recent return of anti-aesthetic strategies derived from the historical avant-gardes, sets out to chart the trajectories and typologies of such artistic practices, proposing the following exemplary definition:

Assemblage is a method with disconcertingly centrifugal potentialities. It is metaphysical and poetic as well as physical and realistic. When paper is soiled or lacerated, when cloth is worn, stained, or torn, when

wood is split, weathered, or patterned with peeling coats of paint, when metal is bent or rusted, they gain connotations which unmarked materials lack. More specific connotations are denoted when an object can be identified as a sleeve of a shirt, a dinner fork, the leg of a rococo chair, a doll's eye or hand, an automobile's bumper, or a social security card. In both situations meaning and material merge. Identities drawn from diverse contexts and levels of value are confronted not only physically, within the limits of the works they form, but metaphysically and associationally.[82]

This passage invokes or conjures the quintessential character of an assemblage as a deliberate lack of compositional order — it is 'disconcertingly centrifugal'. By combining visibly altered or decrepit materials with readymades and *objets trouvés* (or fragments thereof) from various sectors and sources, the method of assemblage, in Seitz's understanding, results in a polysemy that disrupts the classical ideal of unity. His account somehow foreshadows the ways in which, roughly a decade later, Peter Bürger would discuss the nature of such non-organic artworks and their shock effects, although the latter would dismiss the prolongation of such tactics into the neo-avant-gardes as a vacuous and senseless farce devoid of social and political impact.[83] More interested in formalistic continuities than political divergences, Seitz describes how assemblages store and forcibly merge, within the compressed expanse of their given support and format, a wealth of incompatible and ultimately unrelated components, to the point that they appear as if bursting at their seams or, conversely, on the brink of implosion.

Seitz's attempts at definition seem to be informed by the practice of Bruce Conner, whose work was included in the MoMA exhibition. Made between the late 1950s and early 1960s, Conner's assemblages affix or glue together a vast number of appropriated objects and derelict materials — often close to the status of mere rubbish — on various, equally found or retrieved supports, and are held in place and partly covered by nylon stockings.[84] As in Conner's works, in his articulations Seitz tends to stress the dimension of confusion pertinent to an idea of assemblage still steeped in (Neo-) Dadaist notions of dissonance and disturbance. In theoretical terms, his take

comes close to Leo Steinberg's slightly later formulation based mainly on Rauschenberg's contemporaneous combines (also included in 'The Art of Assemblage'). For Steinberg, Rauschenberg's works encapsulate the concept of the 'flatbed picture plane', conceived as 'any receptor surface on which objects are scattered, on which data is entered, in which information may be received, printed, impressed — whether coherently or in confusion'.[85] Regardless of the nod to potential coherence, in both these early definitions, dispersal and randomness appear as the main characteristic of such amalgamations.

At a distance of about four decades — which witnessed the rise of, *inter alia*, (post-)Minimalism, (post-)Conceptualism and Appropriation art — Genzken's *Fuck the Bauhaus* appears as an altogether different object. This series of artworks can no longer be productively or adequately associated with the disruptive and transgressive function of assemblage in modern art history. They beg for a contemporary reassessment. I suggest that by looking closely at the kinds of relations Genzken's assemblages establish between heterogenous parts, we should rather approximate them as *agencements*. Such a mode of analysis can reveal the unexpected alliances and links that emerge by fitting together disparate elements, while not losing sight of the fact that these components — which are not uniform in materiality, morphology or origin — continue to maintain their exteriority and distinctness within new contexts of intimate affiliation. In conversation with French journalist Claire Parnet in 1977, Gilles Deleuze elucidated the concept of assemblage as follows: 'What is an assemblage? It is a multiplicity which is made up of many heterogeneous terms and which establishes liaisons, relations between them [...]. Thus, the assemblage's only unity is that of a co-functioning: it is a symbiosis, a "sympathy".'[86] Not a homogenous whole, but an alliance of distinct yet proximate parts.

Fuck the Bauhaus #1, for instance, presents a relatively sparse architectural model, in which a central mirrored surface is enclosed between two vertical sheets of glass — one textured in white, the other tinted in blue — held together with strips of mostly red and some yellow netting tape. Below, four shells, on one side, and a red toy car of an old-fashioned ambulance, on the other, are arranged in such a way as to suggest the sight of a skyscraper

devoid of façade. On the one hand, these components assemble to form the diorama of a typical (or clichéd) street scene in New York. The ambulance, sporting a logo on the side door and a translucent red siren on its roof, seems to be rushing down the unmarked avenue, passing a skyscraper adorned with a stone garden by its entrance, whose shiny surfaces capture the car's fleeting reflection. Like *I Love New York, Crazy City*, this sculpture is almost cinematic, in the sense of illusionistic, for its precise mode of arranging and affiliating miscellaneous materials and contrasting components. The rigour and austerity of Bauhaus-inspired modern architecture is both turned into travesty and compellingly vitalised through an entertaining glimpse of the action that constantly fills the city's 'mean streets'. At the same time, the manifestly diverse materials, scales and morphologies involved in this assemblage all remain identifiable, precisely in their incommensurability and incompatibility.

Far from heretofore dominant conceptions of assemblage as a 'centrifugal' merging of meaning and material (in Seitz) or a 'flatbed picture plane' (in Steinberg), here, each element or entity, when viewed in isolation, can (re)assume its singular status and signal its independence from the aggregate to which it now belongs, while, at the same time, it participates in projecting the provisional synthesis of an architectural model. That is, all parts are brought into a sensible relation with each other but are not fully determined by nor subsumed into it. Following Bruno Latour's plea concerning the study of specific ties and the forces that make them seem to cohere, Genzken's assemblages allow their beholders to truly engage in the '*tracing of associations*', to discern and enjoy '*a type of connection* between things that are not themselves social'.[87] As a result, these proposals for new buildings in Manhattan imply the liberating potentialities of 're-assocation and reassembling'.[88] Genzken's models 'fuck the Bauhaus' not by negating or destroying its legacies in the present, but by taking up and matching its core shapes and basic structures with actants and elements that are anathematic to them, so as to imagine an urban fabric that harbours virtual mutability and change. Nothing is fixed permanently. All things are not equal so much as associated for the sake of literally and figuratively remodelling the social. Latour writes accordingly (or rather analogically) that the 'social is not

some glue that could fix everything including what the other glues cannot fix; it is what is glued together by many other types of connectors'.[89]

Invariably, Genzken's pioneering brand of assemblage shows signs of dislocation and reintegration at once. All of her sculptural production based on the appropriation and assembly of readymades — whether as part of architectural models or in the more aggressive *theatrum mundi* staged in the reliefs of her *Empire/Vampire* and *The American Room* series (both 2004) — appears both preliminary and complete, contradictory and consistent, disjointed and organised. In contrast to dominant art historical approaches to assemblage, however, the perspective might be reversed when the term is understood as *agencement*, that is, as the arrangement of potentially resolvable connections. Signification, including its dialectical undoing in the sphere of visuality and plasticity, is not achieved through contrast and confusion but rather composition and concatenation. This modality and its effects are particularly evident in *Fuck the Bauhaus #2*. Consisting of vertical white sheets of cardboard and a pizza box, the configuration seems to mimic the structure of a curtain wall as implemented by Walter Gropius for the main building of the Dessau Bauhaus. Adorned with pink plastic flowers on top, *Fuck the Bauhaus #2* is further emblazoned with floral motifs on printed matter and a plastic bag. Held together by wide strips of red tape interspersed by narrower yellow ones, this faux skyscraper is surrounded by pebbles and model trees. Reminiscent of Frank Gehry's computer-designed flourishes, a rolled-up piece of orange construction-site netting serves as a roof ornament, with a small silver chain loosely dangling from the top.[90]

The registers of the syntagmatic and the synthetic once again coincide in this assemblage. For instance, a logotype including the word 'new' appears at the bottom right corner of a plastic bag glued onto one of the cardboard planes, simultaneously standing for itself and denoting a graffito, or 'tag', scrawled on the tower façade by an amateur artist who likely climbed atop the rocks of the stone garden surrounding it. Flowers in different sizes and material renditions abound in this elaborated and perfectly scaled construction. Given the play of proportions, oscillating between small sculpture and projection of urban space, their appearances shuffle back and

forth between the realms of photographic reproduction (both colour and black-and-white) and three-dimensional replica in cheap synthetic material. Examining this meticulous and detailed configuration, it becomes increasingly difficult to distinguish between the interiority and exteriority of its closely interrelated components; that is, between their role and 'reality effect' within the associative, yet convincing composition, on the one hand, and their self-sufficiency as images and items culled from another context, on the other.[91]

The critical literature devoted to Genzken's work in the last two decades has tended to relate her practice to the avant-garde's famed and often rehearsed procedures of montage and collage — an assessment prompted, in part, by the explicit reference made in the title of her pivotal assemblage series. Considering precisely *Fuck the Bauhaus*, art historian Hal Foster argues that while in Genzken's sculptures 'commodity junkspace overwhelms all design schemes', by recalling 'postwar bricoleurs of trash' (such as Kienholz and Rauschenberg) she ends up reanimating 'the artistic lineage ... of Berlin and Zurich Dada'. Introducing the concept of 'mimetic exacerbation' as a tactic of assuming and inflating the conditions of a time through hyperbole or hypertrophy,[92] Foster contends that Genzken,

> *too, practices a mimetic exacerbation of the emergency conditions around her: if those Dadaists exaggerated the subjective effects of both military collapse and political crisis ..., Genzken pushes the distracted-compulsive behavior of the contemporary city dweller of consumerist empire to the edge of breakdown. ... [H]er work stands as an effective diagnosis of our times, the beer belly of post-1989 Germany and post-9/11 America cut and probed with her distinctive kitchen knife.[93]*

Foster squarely positions Genzken's assemblages produced from 2000 onwards within the genealogy of (Neo-)Dada tactics canonised by Seitz and others more than half a century ago. For Foster, Genzken's work repeats the avant-garde techniques of wresting fragments from a crisis-ridden reality that is splintered by media culture, war and consumerism, and of violently compressing them into patently artificial constructs that refuse conventional communication to the point of becoming nearly illegible.

Leaving aside questions of periodisation and the possibility of meaningfully comparing post-First World War Germany to the United States after 9/11, the continuity that Foster claims between Genzken's assemblages and Hannah Höch's collage *Schnitt mit dem Küchenmesser Dada durch die letzte Weimarer Bierbauchkulturepoche Deutschlands* (*Cut with the Kitchen Knife Dada Through the Beer-Belly of the Weimar Republic*, 1919) is as tempting as it is misleading. While Höch's collages assemble a bulk of newspaper cut-outs into chaotic picture planes bursting with parodistic, perhaps outright non-sensical and antagonistic scenes of mismatched proportions — mainly fusing the human body or face with machine parts and political, artistic or commercial slogans — Genzken's works, for all their more or less abysmal contrasts, always envision and strive towards coherence. In other words, her *agencements* leave behind precisely those tenets of avant-garde provocativeness that are based on the aesthetic and epistemic value of shock and estrangement, thus ultimately thwarting their unconditional extension into the present.

Since the mid-1980s, in part informed by the reception of the 1984 English translation from the German of Bürger's *Theory of the Avant-Garde*, North American art historical scholarship of the post-War period has developed and gauged a critical epistemology and historiographic narrative based on the analysis and appreciation of repetitions: the return of paradigms such as the readymade, the monochrome, chance operations and, of course, assemblage.[94] Genzken's *Fuck the Bauhaus* and her more recent architectural models at large arguably mark the limits of this approach. They are not simply a return; instead they open the door to another art of assemblage. As *agencements*, they follow and elicit a different logic of relations between originally incompatible elements, thus exceeding the avant-garde conventions of negation and exacerbation. As such, they demand and deserve another methodology. If practices of the (neo-)avant-garde and attendant art theories, *mutatis mutandis*, stressed negativity, as articulated in moments of shock, mimetic exacerbation or erasure, in order to dialectically usher a utopian alternative to ruling conditions, the making and thinking of *agencement* seeks instead to imagine and elicit scenarios of deviation and defiance, joy and jouissance, beauty and hope, seeing them as immanent to a cacophonous

and complex present that cannot be transcended. After 2000, Genzken stopped relying on and distanced herself from previously internalised and almost taken-for-granted paradigms. In her daring hands, contemporary sculpture probes into and enacts a 'late style' in which 'conventions find expression as the naked representation of themselves'.[95]

Complementing Genzken's architectural models *Beach Houses for Changing*, the 2000 exhibition 'Holiday' featured *Slot Machine*. This piece stands in a long lineage of unflinchingly exposing self-portraits that the artist started making immediately before her earliest models for buildings. Her first *Selbstporträt*, made in 1983 and since destroyed, was an organic stand-in for the artist's self in the guise of a slightly deformed hollow head with openings for eyes, nose and mouth. *My Brain* (1984), a formless plaster piece, complementarily projects both subjective spatial and corporeal experience from obsolete and discarded remnants. Made almost a decade later, in 1991, photographic snapshots of Genzken as a hospital patient sitting in a small bathtub, in *Krankenhausfoto* (*Hospital Photo*), and X-rays of her skull convey a sense of the perils and predicaments of (artistic) subjectivity.[96] Pertaining to this lineage, *Slot Machine* appears also — and more importantly for the present discussion — to showcase the artist's practice of fitting and fixing readymade images and objects, which was just emerging in 1999. It can be seen as a preamble to the far-reaching consequences that such an advanced practice of assemblage might entail both for the sense of artistic selfhood and evocations of contemporary subjecthood at large — a theme further articulated in *Fuck the Bauhaus*.

Following the main theoretical proposition of this book, the subject as fashioned in *Slot Machine* should be regarded as a mere component of a larger *agencement*. In other words, the subject as slot machine belongs to and springs forth from a kind of assemblage that aligns with Gilles Deleuze and Félix Guattari's rejection of the notion of artistic singularity in favour of minor and shared forms of enunciation, as evidenced in the writings of Franz Kafka. Emerging not only in the alienated or mechanised labour performed by men and women but also 'in their adjacent activities, in their leisure, in their loves, in their protestations, in their indignations', these minor forms of enunciation are always technical and social at the same time, 'having men and women as part of [their] gears along with things, structures, metals, materials'.[97] Hence, a portrait that is assembled in such a manner hardly depicts (or even expresses) an enclosed self, let alone the artist as sole originator of an aesthetic articulation.

Slot Machine uses an actual slot machine — like those found in neighbourhood bars and pedestrian gambling halls, often in the vicinity of

train stations — with an unconnected cable protruding from its back and powered by a battery that keeps it running. The wall piece is almost entirely covered by a few strips of yellow and green cellophane (one blocks the coin slot), a host of paper cut-outs from magazines and chromogenic photo prints — all affixed to the slot machine with silver-grey, blue or transparent adhesive tape. Protruding beneath this mass of printed matter, two yellow-lit buttons, some scoreboards and two LED displays of red digits, indicating the amount of money inserted (all set at zero), are visible, revealing the underlying machinery. In the upper centre of the assemblage, between the LED displays, is the shining logotype of a smiling anthropomorphised sun — the trademark of the German company Casino-Merkur and its Spielotheken gambling halls since the mid-1970s.

For the most part arranged in even and regular rows with little overlap between them, the wealth of images attached to *Slot Machine* includes portraits of esteemed artists and collaborators (such as Kai Althoff, Andy Warhol and Lawrence Weiner), celebrities (notably actor Leonardo DiCaprio, fresh from *Titanic*'s recent fame, who is prominently featured twice) and fashion models, combined with urban street scenes and architectural details of buildings and façades probably captured in Manhattan during the making of *I Love New York, Crazy City* a few years earlier. Balancing above this proliferating arrangement is a comparatively large photograph of Genzken looking directly at the beholder. Taken in 1993 by her colleague and friend Wolfgang Tillmans, the loosely framed picture leans against the wall behind a red siren that props up a postcard showing an airliner mid-flight. The composition of these distinct, discernible and denotative elements into an excessively assisted readymade constitutes neither a shrine to an adulated self nor a Hobbesian composite of multiple parts resulting in the self-image of a powerful Leviathan; rather, the artist emerges as surrounded, even besieged, by the presence of others — an onslaught of influence(r)s and impressions, media and architecture, design and consumption. All these heterogenous components find their common ground in a technical apparatus — the slot machine — that imposes the impenetrable and inescapable system of an algorithmically predetermined distribution of chance and accident.[98]

Although singled out by the size and prominent upper position of her own image, Genzken seems to reside quite precariously and preliminarily within this concatenation and association of elements. She appears as a figure, understood not as simple representation of a person's bodily shape and facial features, but in the sense introduced and elaborated by Deleuze in his writings on the paintings of Francis Bacon. For the French philosopher, a 'figure' hardly counts as an isolated phenomenon. Rather than standing on its own and having command of its surroundings, a 'figure' registers as completely assimilated in and utterly indebted to the (pictorial) field in which it is inevitably immersed.[99] As such, it should be regarded as a social subject that is manifested in the mere guise of 'a surface, impressed upon by the outside world', a 'subject ... imagined as a bombarded exterior pummeled by images'.[100] Accordingly, Hal Foster emphasises the radicality implied in 'the trope of the self as a slot machine, in which all play appears scripted (including aesthetic *Spiel*) and all chance automated (beyond anything Duchamp foresaw)'. Relative to the use of architectural terms as correlates of a self-image, in a reading informed by Lacanian psychoanalysis, he concludes 'this ego architecture is broken down'.[101] However, for Foster, the 'critique of the subject' and 'dismantling of the self', as programmatically performed in *Slot Machine*, provides 'a dialectical fillip'. That is, Genzken's work does not rehearse, yet again, the 'death of the author', which had been announced in post-structuralist theory more than three decades earlier, but instead 'valorizes a fragmented ego over a fortified one'.[102]

Genzken's composite configuration offers the puzzling portrait of a self that is surrounded and shaped, perhaps even shredded and slotted by, the particular conditions of contexts and communities it traverses and inhabits. In *Slot Machine*, such a subject, even if still present and identifiable, does not aspire to fathom and convey its singular individuality or personal history. Quite the contrary, it presents itself, in the parlance of 'assemblage theory', as nothing more (but also nothing less) than a case within the entanglements of collective enunciation. This collectivity does not, however, purport to be the 'true subject' (or subject matter) of speech, or, for that matter, of any other mode of representation. As Deleuze and Guattari emphasise in 'What Is an Assemblage?', a chapter in their book-long rumination on Kafka,

originally published in French in 1975, in these instances of artistic production, it becomes utterly useless to ask 'who' the creator is, because it is the processes and procedures of forging assemblages that always already determine the possibility of all statements:

> *[I]t is not enough to say that the assemblage produces the statement as a subject would; it is in itself an assemblage of enunciation in a process that leaves no assignable place to any sort of subject but that allows us all the more to mark the nature and the function of the statements, since these exist only as the gears and parts of the assemblage (not as effects or products).*[103]

Whether they visually feature the figure of the artist or not, Genzken's sculptural assemblages, tend, overall, to externalise the supposedly originating self to the degree that it seems to almost leave the scene. In the critical recalibration of authorship and subjectivity presented in the aesthetics of *agencement*, the artist's self is handed over in the form of protocols of matching and fitting heterogenous items and materials. The assemblages comprising Genzken's late series *Actors*, which premiered at her retrospective at MoMA in New York in 2013 (fig.27), prolong this impulse and method. As *Statthalter* (deputies) of contemporary subjectivity,[104] and unlike the puppets, dolls, automatons and mannequins employed in Dada and Surrealism, these later groupings of mannequins, dressed, draped and furnished with clothes, fabrics, readymade objects, pictures, tape and paint, no longer level a critique at the intrusion of the individual's presumed interiority by commodity fetishism and the objectification of the body.

In dealing with the legacy of the avant-garde, not only does Genzken amplify exteriority through the stark contrast between the uniformity of faces and bodies, on the one hand, and the aplomb and extravagance of their outfitting, on the other; arguably, she also celebrates it as a site from whence one can get rid of the self in order to apotropaically confront the subjectifying forces of everyday life and embrace collectively shared conditions and processes of enunciation. Despite their brash excessiveness, all these ensembles dispel the perplexity conventionally associated with the

fig.26

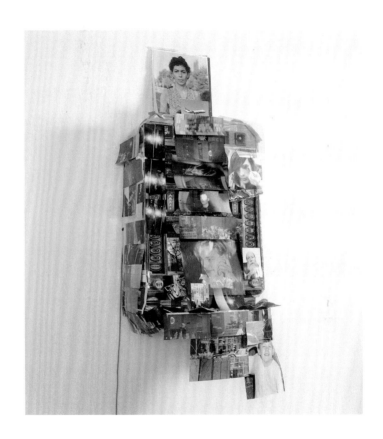

Isa Genzken, *Spielautomat*, 1999–2000, slot machine, paper, chromogenic colour prints, tape, plastic foil, 160×65×50cm. Museum of Modern Art, New York

fig.27

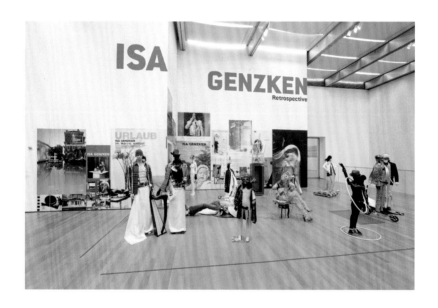

Installation view, 'Isa Genzken: Retrospective', Museum of Modern Art, New York, 2013–14.
© MoMA, New York

fig.28

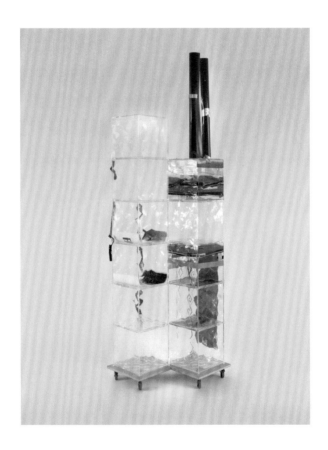

Isa Genzken, *Memorial Tower (Ground Zero)*, 2008, plastic, tape, spray paint, acrylic, mirror foil, filmstrips, colour print on paper, MDF, casters, 316 × 80.5 × 90cm

fig.29

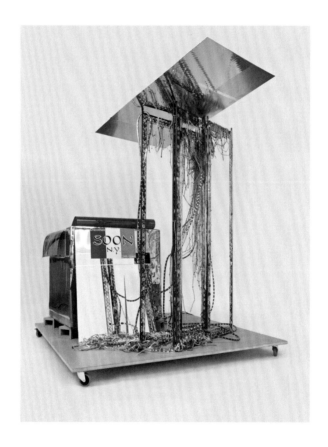

Isa Genzken, *Disco Soon (Ground Zero)*, 2008, cardboard, plastic, mirror, spray paint, acrylic, metal, textile ribbons, light ropes, mirror foil, colour print on paper, MDF, casters 219×205×165cm

fig.30

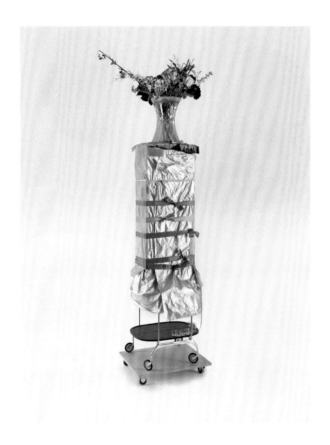

Isa Genzken, *Hospital (Ground Zero)*, 2008, artificial flowers, fabric, plastic, metal, glass, acrylic, spray paint, mirror foil, MDF, casters, 312 × 63 × 76cm

fig.31

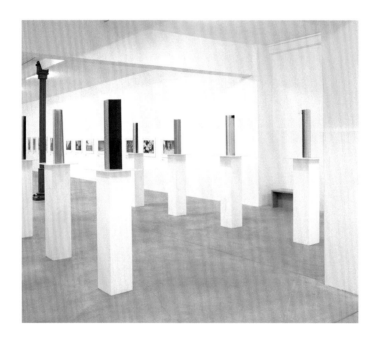

Isa Genzken, *New Buildings for Berlin*, 2001. Installation view, documenta 11, Museum Fridericianum, Kassel 2002. Photo: Werner Maschmann, Kassel

fig.32

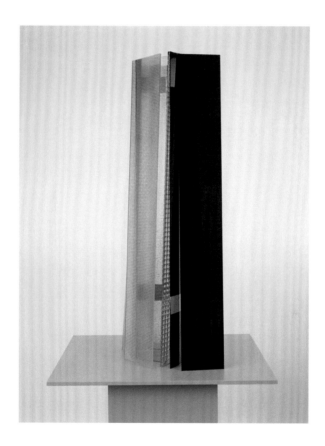

Isa Genzken, *New Buildings for Berlin* (detail), 2004, glass, adhesive tape, epoxy resin, wooden plinth, 225.5 × 60 × 45cm

fig.33

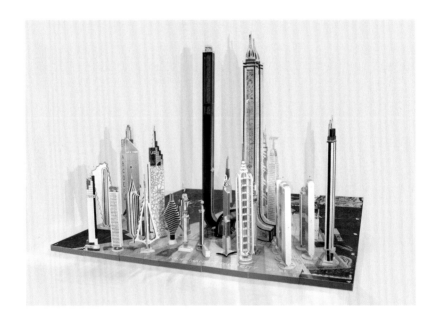

Bodys Isek Kingelez, *New Manhattan (Manhattan City 3021)*, 2002, paper, cardboard, mixed materials, 205×300×280cm © Bodys Isek Kingelez. Photo: Maurice Aeschimann. Courtesy The Jean Pigozzi African Art Collection

art of assemblage in the aftermath of the avant-garde. They figure, instead, a complexity that, following Latour's late reasoning on *agencements*, is not based on compression but on the 'passage through connections'.[105] As the subject (along with its uneven biography and fraught psychology) takes flight in favour of the gears and gambits affiliated with the myriad parts that compose the work, the formal laws and *doxa*, perhaps even the semblance of art, come under duress too. Yet, they necessarily remain in place, even if only to be exposed as conventions and reshuffled.

In a sense, the architectural models Genzken produced after the breakthrough of *Fuck the Bauhaus* can be regarded as yet more manifestations of the artist's 'late style'. The consolidation of a shift from assemblage to *agencement* leads to the irrefutable impression that conventions, as put by Theodor W. Adorno in his ruminations on late style, 'are no longer penetrated and mastered by subjectivity, but simply left to stand'.[106] In Adorno's understanding (and critical project of negative dialectics), the conventions that were abandoned yet remain discernible in late works are those of (musical) harmony, composition and logical tonality. In Genzken's case, the convention of transgressing these very conventions — or the conventionalisation of the (neo-)avant-garde — is left to stand without the need to fully obey it; it is invoked as a matrix now unable to leave an imprint. The aesthetics of the Bauhaus — and what it stands for in modern culture and its aftermaths — are not just overthrown or colloquially 'fucked over'. Alleviated from the burden of warding off contamination, the revived modernist aesthetic is allowed to absorb the impurity, even violence, of the life it once sought to redesign and reform. Departing from the canonised avant-garde tactics of making compressed amalgamations of incommensurable materials, these sculptures manage instead to establish meaningful filiations and alliances, grounded in both the heterogeneity and compatibility of their various and varied components.

First shown at Hauser & Wirth in London in the spring of 2008, Genzken's suite of seven works called *Ground Zero* again imagine and evoke alternative additions to the Manhattan skyline, this time in the aftermath of the attacks and destruction of 9/11. Each sculpture is balanced on plywood pedestals on wheels — which doubled as trollies and carts during the process

of creation – and these shaky foundations stress virtual mobility, but also the precarity of the structures. Belatedly and somehow preposterously, the makeshift models make earnest, as much as ambitious, proposals for the architectural competition held five years earlier, in 2003, to reconstruct the southern tip of the island of Manhattan after the fall of the Twin Towers World Trade Center. The winning plan for the competition was a corporate 'Freedom Tower' (now One World Trade Center) designed by Studio Libeskind.[107] The accompanying catalogue of *Ground Zero*, encompassing photomontages concocted by Zappe Architekten in Berlin, mimics and seemingly mocks the design strategies rampant in professional architectural firms' submissions to clients.[108]

Genzken's perfectly scaled *Ground Zero* models emphasise a range of social and collective aspects of urban life already present in *I Love New York, Crazy City*, here regaining prominence and traction in the wake of disaster and despair. Spaces of retail appear in the provocatively titled *Osama Fashion Store,* an apparently unassuming bricolage of transparent polycarbonate baskets, the tilted upper one containing plastic shoppers and a spray-painted pillow. Worship is addressed in *Church*, a gridded industrial cart covered in translucent yellow and green plastic sheets, and crowned by an improvised cross sporting a toy skull. Historical commemoration for this highly mediatised catastrophe is offered in *Memorial Tower* (fig.28), in which a pair of vertically stacked, semi-transparent and wrinkled plastic cubes are arranged so as to emulate the destroyed Twin Towers. Outfitted with dangling undeveloped filmstrips, the cubes contain upside-down photographs of scenes from 9/11 – a withdrawal of visuality that registers as resistance to the relentless coverage of the event. In *Light*, public illumination is hinted at through a wild construction of intersecting metal stanchions adorned with debased art deco floral lampshades; while in *Car Park*, traffic congestion and the ubiquity of the car are denoted through a stack of coloured plastic fruit bowls filled with miniature cars. Most poignantly, Genzken's daring and exuberant assemblages *Disco Soon* (fig.29) and *Hospital* (fig.30) offer glimpses of the promises and possibilities immanent in an *architecture parlante* devoted to pleasure and play, communality and care, amidst the limitations and restrictions of corporate

power and political Manichaeism dominant in the era of the US-led 'war on terror'.

Disco Soon comprises a big cardboard box covered with sheets of faux mirror and coloured plaster foil, on which paint has been messily applied. The work seems to owe its title to a sticker glued on a slanted mirror, leaning against one of the box's sides, which reads 'Discothek/SOON/N.Y./24h open' against the backdrop of the French flag. In front of the cardboard box, which serves as the main building of the nightclub, are tall metal frames. Standing vertically on the wooden podium, they are draped with lit hose lights and strands of beads, and capped by an aslant metal plate partially covered by glitzy golden tiles. As Yve-Alain Bois has noted, 'because the chaos of its flashy beads stumbling to the floor is more festive than the regimented decor of the usual discotheque, *Disco "Soon"* [sic] might be read as staging a revenge of the material against robotized entertainment, the innards of architecture suddenly spilling over'.[109] If Genzken's sculpture means to suggest the site and structure of a dance venue, a place of joy and intoxication that never sleeps, its reliance on the sovereignty of the appropriated material potentially undercuts and transforms its intended function. Following the principles of *agencement*, a legible meaning is to be derived from the connections established between elements that retain, at the same time, their sense of displacement and exteriority, as in the flamboyant Broadway scenery in *Fuck the Bauhaus #4*. Even though all the components are brought into a definitive but ludic compositional constellation, the assemblage nonetheless exceeds its conventions precisely by relenting the grasp on its constituent material. The rules applied in forging the 'unstable alliance of matter and image' that constitutes a work of art (and its inexhaustible alterity) no longer register as formally binding.[110] All components are at once interior and exterior to the architectural model they mediate and make up.

Hospital, by the same token, consists of a drinks trolley carrying nine empty shot glasses and balancing somewhat precariously on its wheeled plywood plinth. Its unstable base is elongated by spray-painted hollow cardboard boxes almost entirely wrapped in aluminium foil and greenish fabric and fastened with gift ribbons of various hues and widths. A bouquet of artificial flowers is perched atop and held together in a curved silverish

vase, with stains of red and green paint. The most common present gifted
to hospitalised friends becomes the figurative crown of a future building
dedicated to medical care and healing, at a site of both violence and rescue.
Here, again, a high-rise building is invoked solely through the association
of items and materials that remain distinct, although primarily identifiable,
in the part they play to project an idea for a place far beyond the ordinary,
coordinated in its every detail and rationale.

In light of Genzken's (post-)Minimalist beginnings, *Ground Zero*,
as much as *Fuck the Bauhaus*, can be considered a 'late work'. As per Adorno's
definition, late works 'are, for the most part, not round, but furrowed, even
ravaged', and marked by an 'overabundance of material'.[111] In his 1937 short
essay 'Late Style in Beethoven', the philosopher argues against the (then
and still) common view that the exceedingly dissonant 'late works of significant
artists' are 'products of an uninhibited subjectivity, or, better, "personality",
which breaks through the envelope of form to better express itself,
transforming harmony into the dissonance of its suffering'.[112] Seen this
way, 'late works are relegated to the outer reaches of art, in the vicinity of
document', and the references made 'to biography and fate' begin to dominate
and lead the 'theory of art ... to divest itself of its rights and abdicate in
favor of reality'.[113] For Adorno, the 'inadequacy of this view becomes evident
as soon as one fixes one's attention not on the psychological origins,
but on the work itself'.[114] In the case of Genzken — an artist who has spoken
of her experience of bipolar disorder and manic depression since the late
1990s[115] — the Adornian rejection of biographical or psychological readings
of artworks seems particularly pertinent and instructive. Her late and puzzling
foray into a radically redefined practice of sculptural assemblage should
not be seen as displaying a sudden lack of interest in formal resolution, or
even an 'indifference to appearances'.[116] Not the concept of 'expression' but
the 'formal law' guiding late works, which, as I argue, is reflected in the
various theories of *agencement*, needs to guide their critical consideration.[117]

For Adorno, it is the 'relationship of the conventions to the subjectivity
itself' that 'must be seen as constituting the formal law from which the content
of the late works emerges'.[118] According to this complex and demanding 'law',
artistic subjectivity does not reign without inhibition over allegedly anomic

works, let alone ravage them. Quite the contrary, it is relinquished so that the 'masses of material' can be set free from the conventions hitherto used to control and shape them.

The power of subjectivity in the late works of art is the irascible gesture with which it takes leave of the works themselves. It breaks their bonds, not in order to express itself, but in order, expressionless, to cast off the appearance of art. Of the works themselves it leaves only fragments behind, and communicates itself, like a cipher, only through the blank spaces from which it has disengaged itself.[119]

From this vantage point, Genzken's specific mode of assembling architectural models replaces the articulations of 'the solitary I' with the expressiveness of artistic conventions that, once liberated from the grip of subjectivity, 'as splinters, fallen away and abandoned ... finally revert to expression'.[120] From *Fuck the Bauhaus* onwards (and in slightly earlier works such as *Slot Machine* and *I Love New York, Crazy City*), her sculptures disidentify from both the myth of individual expressivity and the avant-garde tradition of *épater le bourgeois* (shock the middle class). The inherited tropes are opened up to a different field of object relations in which, after Deleuze and Guattari, 'a collective assemblage of enunciation' meets 'a machinic assemblage of desire'.[121] Therein lies their decidedly contemporary signature.

If the very term *contemporary*, as art historian David Joselit has argued, 'has shifted from an adjective to a noun' and hence no longer designates only coevalness but also a period in the history of art composed of 'loosely related aesthetic tendencies'[122] and their attendant methodologies on a global scale, Genzken's redefined practice of sculptural assemblage is both indicative of this very development and illuminating for its (admittedly tentative and modest) theorisation. Okwui Enwezor's curatorial constellation at documenta11 of another suite of Genzken's architectural models, *New Buildings for Berlin* alongside Congolese artist Bodys Isek Kingelez's *New Manhattan (Manhattan City 3021)* (2002, fig.33) may prove revealing in this regard, suggesting a deeper level of connection than the mere morphological proximity of skyscrapers. Made of found pieces of balsa wood, cardboard,

paper and ink, Kingelez's vibrant and highly ornamental designs reject
the modernist grids and functional architecture commonly associated with
the neocolonial aesthetics of developmentalism prompted in part by the
export of Bauhaus principles in the post-War period. In his own response
to the 9/11 attacks, Kingelez proposed the organic dynamism and decorative
qualities of a future urban landscape, perhaps utopian, in line with his
previous architectural visions for prosperous and democratic African countries
(especially, but not exclusively, in his native Democratic Republic of Congo).

In its immediate vicinity, Genzken's series *New Buildings for Berlin*
elegantly, but no less fervently, intervenes in the urban planning of the
German capital. Its rectangular strips of clear, textured or coloured glass
imagine high-rise buildings that are dramatically different from the then
approved reconstruction of Potsdamer Platz in Berlin, located at the former
border between East and West Germany, with its anonymous corporate
architecture.[123] Leaning against each other, sustained only (like her *Beach
Houses*) by gravity (and some tape), and mounted at eye level on slim white
pedestals, these reduced assemblages suspend, once again, their respective
components between the poles of self-sufficiency and exteriority (as shards
of glass) and denotation and interiority (as glass curtains of skyscrapers).
Beyond their obvious, quite deflating references to Walter Gropius, Ludwig
Mies van der Rohe, Richard Serra and other male artists with (late-)
modernist convictions, these decorative, lush and fragile sculptures project
a powerful alternative to corporate architecture forged precisely from
aesthetic dullness and ideological ruination. As *agencements* based
on methods of fitting and fixing, of filiation and (re)formation, Genzken's
New Buildings for Berlin and for New York move far beyond the repetition
of avant-garde tactics and tenets, towards the anticipation of alternative
scenarios of everyday beauty, communality and joy. *Fuck the Bauhaus.*

NOTES

1 Isa Genzken's solo exhibition 'Fuck the Bauhaus (New Buildings for New York)' was on view at AC Project Room from 7 October to 18 November 2000.

2 Genzken's *Fuck the Bauhaus* series includes three additional assemblages (*#7, #8, #9*). Rather than engaging with the language of architectural models, these three assemblages present derailed commodities: a box filled with materials including a Kodak film container and a powder brush; crumpled-up silver paper framed by netting to form a faux camellia broch; a small, deformed, soiled shopping bag bursting with stuff, including a wrinkled jelly beans bag. These assemblages were not shown at the AC Project Room.

3 Also on view was an earlier instantiation of Genzken's *Deutsche Bank Vorschlag* (*Deutsche Bank Proposal*, 2000), modelled on Philip Johnson's famous 1984 AT&T building on Madison Avenue in New York. Adorned with two antennae, the skyscraper turned into a media device is reminiscent of the artist's series *Weltempfänger* (*World Receivers*, begun 1987), cast-concrete blocks with inserted telescoped rods. See Tom Mc Donough, 'Fuck the Bauhaus', in *Isa Genzken. Sesam, öffne dich!*, Cologne: Verlag der Buchhandlung Walther König, 2009, p.154.

4 Lisa Lee, *Isa Genzken: Sculpture as World Receiver*, Chicago: University of Chicago Press, 2017, p.79.

5 *Ibid.*, pp.79–80.

6 For condensed histories of modern(ist) sculpture and beyond, see Benjamin H.D. Buchloh, 'Die Konstruktion (der Geschichte) der Skulptur', in Klaus Bussmann and Kasper König (ed.), *Skulptur Projekte in Münster 1987* (exh. cat.), Münster and Cologne: Westfälisches Landesmuseum für Kunst und Kulturgeschichte and Dumont Buchverlag, 1987, pp.329–58; and Simon Baier, 'Speaking without a Tongue', in *Sculpture on the Move: 1946–2016* (exh. cat.), Basel and Ostfildern: Kunstmuseum Basel and Hatje Cantz, 2016, pp.42–50. For one of the definitive accounts of the theoretical implications of Minimalist sculpture, see Hal Foster, 'The Crux of Minimalism' (1986), in *The Return of the Real: The Avant-Garde at the Turn of the Century*, Cambridge, MA: MIT Press, 1996, pp.35–70.

7 Rosalind E. Krauss, 'Sculpture in the Expanded Field' (1978), *October*, vol.8, Spring 1979, pp.30–44; on the impact of Krauss's essay, see Spyros Papapetros and Julian Rose (ed.), *Retracting the Expanded Field: Encounters between Art and Architecture*, Cambridge, MA: MIT Press, 2014.

8 B.H.D. Buchloh, 'All Things Being Equal', *Artforum*, vol.44, no.3, November 2005, pp.222–25; and B.H.D. Buchloh, 'New Sculpture', in *Art Since 1900: Modernism, Antimodernism, Postmodernism* (ed. H. Foster, R.E. Krauss, Yve-Alain Bois, B.H.D. Buchloh and David Joselit), 2nd ed., London: Thames & Hudson, 2012, pp.724–31.

9 *Ibid.*

10 David Joselit has characterised 'the contemporary … as a period, composed of loosely related aesthetic tendencies, following and displacing modernism'. D. Joselit, 'On Aggregators', *October*, vol.146, Fall 2013, p.3.

11 Peter Osborne, *Anywhere Or Not At All: Philosophy of Contemporary Art*, London: Verso, 2013, p.86.

12 Briony Fer, 'Isa Genzken: Whitechapel Gallery', *Artforum*, vol.47, no.10, Summer 2009, p.324. In her essay for the catalogue of the retrospective she co-curated with Sabine Breitwieser, curator Laura Hoptman neutrally states that 'Genzken radically changed her aesthetic strategy, moving away from the constructed object towards the assembled one'. L. Hoptman, 'Isa Genzken: The Art of Assemblage, 1993–2013', in *Isa Genzken: Retrospective* (exh. cat.), New York: Museum of Modern Art, 2013, p.131.

13 B.H.D. Buchloh, 'All Things Being Equal', *op. cit.*, p.225.

14 In their 1975 book on Franz Kafka, for example, Gilles Deleuze and Félix Guattari state, regarding the general logic of assemblages (as *agencenements*), that in the German-Czech author's writings 'the molecular multiplicity tends itself to become integrated with, or make room for, a machine, or rather a *machinic assemblage*, the parts of which are independent of each other, but which functions nonetheless'. G. Deleuze and F. Guattari, *Kafka: Toward a Minor Literature* (trans. Dana Polan), Minneapolis: University of Minnesota Press, 1986, p.37. Emphasis in the original. Social theorist and historian of science Bruno Latour has developed a notion of assemblage in terms of an association of actors and actants, that is, networks of human, technological (and biological) elements in which agency is performed and redistributed. See, for example, B. Latour, *Reassembling the Social: An Introduction to Actor-Network-Theory*, Oxford: Oxford University Press, 2005. For a

succinct introduction to the (Deleuzian) notion of assemblage, see Manuel DeLanda, *Assemblage Theory*, Edinburgh: Edinburgh University Press, 2016.

15 See Thomas Nail, 'What is an Assemblage?', *SubStance*, vol.46, no.1, issue 142, 2017, pp.21–37.

16 Y.-A. Bois, 'The Bum and the Architect' (2007), in L. Lee (ed.), *Isa Genzken, October Files*, vol.17, Cambridge, MA: MIT Press, 2015, p.166.

17 Peter Bürger, *Theory of the Avant-Garde* (trans. Michael Shaw), Minneapolis: University of Minnesota Press, 1984, pp.70 and 72.

18 *Ibid.*, p.81.

19 *Ibid.*, p.78.

20 *Ibid.*, p.80.

21 Y.-A. Bois, 'The Bum and the Architect', *op. cit.*, p.178.

22 *Ibid.*, p.180.

23 P. Bürger, *Theory of the Avant-Garde*, *op. cit.*, p.74.

24 Juliane Rebentisch, 'The Dialectic of Beauty: On the Work of Isa Genzken', in L. Lee (ed.), *Isa Genzken, October Files*, *op. cit.*, pp.157–58.

25 A facsimile of the tripartite artist book was published a decade later: Beatrix Ruf (ed.), *Isa Genzken. I love New York, Crazy City*, Geneva: JRP Ringier/Editions S.A., 2006.

26 Griselda Pollock, 'Not Wandering within Diversity', in Søren Grammel (ed.), *Isa Genzken — Works from 1973 to 1983*, Cologne: Verlag der Buchhandlung Walther König, 2021, p.40.

27 *Ibid.*

28 Kenneth Frampton, 'Towards a Critical Regionalism. Six Points for an Architecture of Resistance' (1983), in H. Foster (ed.), *The Anti-Aesthetic. Essays on Postmodern Culture*, New York: The New Press, 1998, pp.17–34.

29 Birgit Pelzer, 'Axiomatic Subject to Withdrawal' (1979), in L. Lee (ed.), *Isa Genzken, October Files*, *op. cit.*, pp.7–12. Genzken's *Ellipsoids* were featured alongside photographic works in another exhibition at the gallery in 1981 and also included, at the Fridericianum, in documenta 7 in Kassel in 1982.

30 B.H.D. Buchloh, 'Isa Genzken: The Fragment as Model' (1992), in L. Lee (ed.), *Isa Genzken, October Files*, *op. cit.*, p.19.

31 K. Frampton, 'Towards a Critical Regionalism', *op. cit.*, p.22.

32 *Ibid.*, p.23. Emphasis in the original.

33 B.H.D. Buchloh, 'Isa Genzken: Fuck the Bauhaus: Architecture, Design, and Photography in Reverse'

(2014), in L. Lee (ed.), *Isa Genzken, October Files*, *op. cit.*, p.36. Also see L. Lee, *Isa Genzken: Sculpture as World Receiver*, *op. cit.*, p.55. It should be noted that Buchloh's essay, despite its title, does not analyze Genzken's assemblages from 2000, but presents a study of Genzken's artist book *Berlin 1973* (1973). However, it implicitly points to the continuity in Genzken's approach to avant-garde culture in general and the Bauhaus tradition in particular.

34 K. Frampton, 'Towards a Critical Regionalism', *op. cit.*, p.20.

35 *Ibid.*, p.21.

36 *Ibid.*, pp.28–33.

37 Sylvia Lavin, 'One to What? Cultural Technique and Model Making', *e-flux Architecture*, November 2022, n.p., available at https://www.e-flux.com/architecture/on-models/501142/one-to-what-cultural-technique-and-model-making/.

38 Stefan Vervoort, *Models Beyond Sculpture: Architectural Objects in the Visual Arts in New York and Düsseldorf, 1966–1984*, Gent: Universiteit Gent, Faculteit Letteren en Wijsbegeerte, 2020, p.92. The loose formation of 'model makers' includes the artists Ludger Gerdes, Harald Klingelhöller, Reinhard Mucha and Thomas Schütte as well as — or at least in close proximity to — Tony Cragg, Katharina Fritsch, Hubert Kiecol, Martin Kippenberger and Hermann Pitz.

39 On the *Ellipsoids*, see L. Lee, *Isa Genzken: Sculpure as World Receiver*, *op. cit.*, pp.34–35. On the turn from Genzken's stereometric sculptures to 'an almost primitive simplicity', see Sabine Breitwieser, 'The Characters of Isa Genzken: Between the Personal and the Constructive, 1970–1996', in *Isa Genzken: Retrospective*, *op. cit.*, pp.37–38.

40 Jutta Koether, 'Women also hunted', in *Isa Genzken — Works from 1973 to 1983*, *op. cit.*, p.53.

41 Robert Smithson, 'The Monuments of Passaic: Has Passaic replaced Rome as The Eternal City?', *Artforum*, vol.6, no.4, December 1967, p.50.

42 J. Koether, 'Women also hunted', *op. cit.*, p.54. Emphasis in the original.

43 *Ibid.*, p.53.

44 Christine Mehring, 'Modest Abstraction: Thomas Schütte's Early Work', in Lynne Cooke (ed.), *Thomas Schütte: Hindsight* (exh. cat.), Madrid: Museo Nacional Centro de Arte Reina Sofia, 2010, p.34.

45 S. Vervoort, *Models Beyond Sculpture, op. cit.*, p.232.

46 Bernd and Hilla Becher, *Anonyme Skulpturen. Eine Typologie technischer Bauten*, Düsseldorf: Art-Press, 1970.

47 S. Breitwieser, 'The Characters of Isa Genzken', *op. cit.*, p.39.

48 B.H.D. Buchloh, 'Isa Genzken: The Fragment as Model', *op. cit.*, p.28.

49 L. Lee, *Isa Genzken: Sculpure as World Receiver*, *op. cit.*, p.55.

50 B.H.D. Buchloh, 'Isa Genzken: The Fragment as Model', *op. cit.*, p.31.

51 *Ibid.*

52 S. Breitwieser, 'The Characters of Isa Genzken', *op. cit.*, p.39.

53 L. Lee, *Isa Genzken: Sculpure as World Receiver*, *op. cit.*, p.8.

54 *Ibid.*

55 *Ibid.* See also Roland Mönig, Simene Scholten and Guido de Werd (ed.), *Joseph Beuys. 'Straßenbahnhaltestelle'. Ein Monument für die Zukunft*, Cleve, Germany: Museum Kurhaus Kleve, 2000.

56 Arjun Appadurai, 'Commodities and the Politics of Value', in *The Social Life of Things: Commodities in Cultural Perspective*, Cambridge: Cambridge University Press, 1986, p.57.

57 J. Rebentisch, 'The Dialectic of Beauty', *op. cit.*, p.150.

58 *Ibid.*

59 *Ibid.*, p.154.

60 *Isa Genzken. Jeder braucht mindestens ein Fenster*, Cologne: Verlag der Buchhandlung Walther König, 1992.

61 J. Rebentisch, 'The Dialectic of Beauty', *op. cit.*, p.157.

62 *Ibid.*

63 *Ibid.*

64 M. DeLanda, *Assemblage Theory, op. cit.*, p.1.

65 Roland Barthes, 'The World as Object' (1953; trans. Richard Howard), in *Roland Barthes: Critical Essays*, Evanston, IL: Northwestern University Press, 1972, p.3.

66 *Ibid.*, p.5.

67 'Diedrich Diederichsen in Conversation with Isa Genzken', in *Isa Genzken, October Files, op. cit.*, pp.122–23.

68 *Ibid.*, p.123.

69 Sergei Eisenstein, 'Montage of Attractions: For "Enough Stupidity in Every Wiseman"', *The*

Drama Review, vol.18, no.1, March 1974, pp.77–85.

70 In his reading of *I Love New York, Crazy City*, Yve-Alain Bois likewise emphasises that 'a certain order is maintained' and that despite the fact that the artist's editorial choices may 'signify non-choice', 'some double spreads are clearly focusing on certain "themes"'. Y.-A. Bois, 'The Bum and the Architect', *op. cit.*, pp.164–65.

71 B. Latour, *Reassembling the Social, op. cit.*, p.166.

72 L. Hoptman, 'Isa Genzken: The Art of Assemblage', *op. cit.*, p.142.

73 Y.-A. Bois, 'The Bum and the Architect', *op. cit.*, p.176.

74 Alex Farquharson, 'What Architecture Isn't', in *Isa Genzken*, London: Phaidon Press, 2006, p.101.

75 Susan Sontag, 'Notes on Camp', *Partisan Review*, vol.31, no.4, Fall 1964, pp.518–19.

76 This rather unknown work is brought into rapport with Genzken's *Beach Houses* in A. Farquharson, 'What Architecture Isn't', *op. cit.*, p.76.

77 David Bussel, '*Urlaub*', in *Isa Genzken. Sesam, öffne dich!*, *op. cit.*, p.153.

78 J. Rebentisch, 'The Dialectic of Beauty', *op. cit.*, p.159.

79 Pamela M. Lee hence has stated: 'With the *Strandhäuser zum Umziehen* […] series, Genzken offers a perspective into the intimate workings of domestic life and its phantasmatic projections; here, the external constructions of vacation homes act as inverted screens or mirrors for psychosexual desire and fantasies of retreat from the world outside.' P.M. Lee, 'The Skyscraper at Ear Level', in *Isa Genzken, October Files, op. cit.*, p.89.

80 Y.-A. Bois, 'The Bum and the Architect', *op. cit.*, p.178.

81 Despite the major contributions, in different historical periods, by women artists such as Hanne Darboven, Louise Nevelson, Howardena Pindell and Betye Saar, to mention a few, this canon still persists in the critical literature. Undeniably, it has also been formative for Genzken's (queered) practice of assemblage, as her chosen affiliations with exclusively male artists attest.

82 Wiliam C. Seitz, 'The Poetry and Realism of Assemblage', in *The Art of Assemblage* (exh. cat.), New York: Museum of Modern Art, 1961, pp.85–86.

83 On the contemporary legacy of the readymade, Bürger famously wrote: 'If an artist today signs a stove pipe and exhibits it, that artist certainly does not denounce the art market but adapts to it.

Such adaptation does not eradicate the idea of individual creativity, it affirms it, and the reason is the failure of the avant-gardiste intent to sublate art. Since now the protest of the historical avant-garde against art as institution is accepted as *art*, the gesture of protest of the neo-avant-garde becomes inauthentic.' P. Bürger, *Theory of the Avant-Garde, op. cit.*, pp.52–53.

84 Y.-A. Bois, '1959b', in H. Foster, R. Krauss, Y.-A. Bois and B.H.D. Buchloh, *Art Since 1900, op. cit.*, p.417. On the art of Bruce Conner, see Kevin Hatch, *Looking for Bruce Conner*, Cambridge, MA: MIT Press, 2016.

85 Leo Steinberg, 'Other Criteria' (1968), in *Other Criteria: Confrontations with Twentieth-century Art*, Oxford: Oxford University Press, 1972, p.84.

86 G. Deleuze and Claire Parnet, *Dialogues II* (trans. Hugh Tomlinson and Barbara Habberjam), revised edition, New York: Columbia University Press, 2002, p.69.

87 B. Latour, *Reassembling the Social, op. cit.*, p.5. Emphasis in the original.

88 *Ibid.*, p.7.

89 *Ibid.*, p.5.

90 P.M. Lee, 'The Skyscraper at Ear Level', *op. cit.*, p.74.

91 Regarding the 'reality effect' achieved by seemingly superfluous details in realist art, see R. Barthes, 'The Reality Effect' (1969), in *The Rustle of Language* (ed. Francois Wahl, trans. R. Howard), Berkeley: University of California Press, 1989, pp.141–48. On the crucial importance of the aspects of interiority and exteriority for the relations within *agencements*, see M. DeLanda, *Assemblage Theory, op. cit.*, p.2.

92 H. Foster, 'Dada Mime', *October*, vol.105, Summer 2003, p.169.

93 H. Foster, 'Fantastic Destruction', in *Isa Genzken, October Files, op. cit.*, pp.198–99.

94 See B.H.D. Buchloh, 'The Primary Colors for the Second Time: A Paradigm Repetition of the Neo-Avant-Garde', *October*, vol.37, Summer 1986, pp.41–52; and H. Foster, 'Who's Afraid of the Neo-Avantgarde', in *The Return of the Real op. cit.*, pp.1–34.

95 Theodor W. Adorno, 'Late Style in Beethoven' (1937; trans. Susan H. Gillespie), in *Essays on Music* (ed. Richard Leppert), Berkeley: University of California Press, 2002, p.566.

96 See 'A Conversation with Wolfgang Tillmans', in *Isa Genzken, October Files, op. cit.*, p.107.

97 G. Deleuze and F. Guattari, *Kafka, op. cit.*, p.81.

98 On the question of technologically induced randomness in contemporary art, see André Rottmann, 'Randomizing Painting: Notes on Richter's Abstractions', in B.H.D. Buchloh, Sheena Wagstaff and Brinda Kumar (ed.), *Gerhard Richter: Painting After All*, New York and New Haven: Metropolitan Museum of Art and Yale University Press, 2020, pp.82–93 and 258–60.

99 G. Deleuze, *Francis Bacon: The Logic of Sensation* (trans. Daniel W. Smith), London: Continuum, 2003, pp.8–19.

100 Alex Kitnick, 'The Brutalism of Art and Life', *October*, vol.136, Spring 2011, p.86. My reading of Deleuze's notion of 'figure' is indebted to Kitnick's analysis of the concept as part of his engagement with Eduardo Paolozzi's Pop sculptures and bas-reliefs.

101 H. Foster, 'Fantastic Destruction', *op. cit.*, p.198.

102 *Ibid.*

103 G. Deleuze and F. Guattari, *Kafka, op. cit.*, p.84.

104 T.W. Adorno, 'The Artist as Deputy' (1953; trans. Shierry Weber Nicholson), in *Notes to Literature* (ed. Rolf Tiedemann), New York: Columbia University Press, 2019, pp.112–20.

105 B. Latour, *Facing Gaia: Eight Lectures on the New Climatic Regime* (trans. Catherine Porter), Cambridge, MA: Polity, 2017, p.135.

106 T.W. Adorno, 'Late Style in Beethoven', *op. cit.*, p.566.

107 Libeskind's office building is complemented by the WTC underground transportation hub and a memorial site, the National September 11 Memorial & Museum, designed by architect Michael Arad and completed in 2014.

108 L. Lee, *Isa Genzken: Sculpture as World Receiver, op. cit.*, p.80; Y.-A.Bois, 'The Bum and the Architect', *op. cit.*, pp.167–68.

109 *Ibid.*

110 D. Joselit, *Art's Properties*, Princeton, NJ: Princeton University Press, 2023, p.12.

111 T.W. Adorno, 'Late Style in Beethoven', *op. cit.*, pp.564 and 566. On the relationship of Genzken's mode of assemblage and the concept of 'late style', see also A. Rottmann, 'Keine Kapitulation, nirgends. Über Isa Genzken im Museum Ludwig, Köln', *Texte zur Kunst*, vol.19, no.76, December 2009, pp.236–41. As this book goes to print, art historian George Baker has conceptualised, with recourse to Adorno's essay on Beethoven, various artistic uses of analogue technologies relative to photography (and film) since the 1990s as

engaging with the lateness of the medium and
thereby unleashing critical forces of anachronisms
under the aegis of digitalisation. See George
Baker, *Lateness and Longing: On the Afterlife
of Photography*, Chicago: University of Chicago
Press, 2023, especially pp.10–12 and 62–63.

112 T.W. Adorno, 'Late Style in Beethoven', *op. cit.*,
p.564.

113 *Ibid.*

114 *Ibid.*

115 Ulf Lippitz and Nicola Kuhn, 'Künstlerin Isa
Genzken im Interview. "Zu Tokio Hotel tanze
ich wie ein Teenager"', *Tagesspiegel*, 29 June 2016.

116 T.W. Adorno, 'Late Style in Beethoven', *op. cit.*,
p.566.

117 *Ibid.*, p.164.

118 *Ibid.*, p.566.

119 *Ibid.* As Edward Said commented in relation to
Adorno's essay: 'Lateness is a kind of self-imposed
exile from what is generally acceptable, coming
after it, and surviving beyond it.' E. Said, *On Late
Style: Music and Literature Against the Grain*, New
York: Pantheon Books, 2006, p.16.

120 T.W. Adorno, 'Late Style in Beethoven', *op. cit.*,
p.566.

121 G. Deleuze and F. Guattari, *Kafka, op. cit.* p.81.

122 D. Joselit, 'On Aggregators', *op. cit.*, p.3.

123 L. Lee, *Isa Genzken: Sculpture as World Receiver*,
op. cit., p.67.

Jeff Wall:
PICTURE FOR WOMEN
by David Campany

Jeff Koons:
ONE BALL TOTAL
EQUILIBRIUM TANK
by Michael Archer

Richard Hamilton:
SWINGEING
LONDON 67 (F)
by Andrew Wilson

Martha Rosler:
THE BOWERY
IN TWO INADEQUATE
DESCRIPTIVE SYSTEMS
by Steve Edwards

Dan Graham:
ROCK MY RELIGION
by Kodwo Eshun

Yayoi Kusama:
INFINITY MIRROR
ROOM – PHALLI'S FIELD
by Jo Applin

Michael Asher:
KUNSTHALLE BERN, 1992
by Anne Rorimer

Sanja Iveković:
TRIANGLE
by Ruth Noack

Hélio Oiticica and Neville D'Almeida:
BLOCK-EXPERIMENTS IN
COSMOCOCA – PROGRAM
IN PROGRESS
by Sabeth Buchmann and Max Jorge Hinderer Cruz

General Idea:
IMAGEVIRUS
by Gregg Bordowitz

Philip Guston:
THE STUDIO
by Craig Burnett

Thomas Hirschhorn:
DELEUZE MONUMENT
by Anna Dezeuze

Mike Kelley:
EDUCATIONAL COMPLEX
by John Miller

Lee Friedlander:
THE LITTLE SCREENS
by Saul Anton

Agnes Martin:
NIGHT SEA
by Suzanne Hudson

Sturtevant:
WARHOL'S MARILYN
by Patricia Lee

Sigmar Polke:
GIRLFRIENDS
by Stefan Gronert

David Hammons:
BLIZ-AARD BALL SALE
by Elena Filipovic

Walker Evans:
KITCHEN CORNER
by Olivier Richon

Sharon Lockhart:
PINE FLAT
by Howard Singerman

Mark Leckey:
FIORUCCI MADE ME
HARDCORE
by Mitch Speed

Beverly Buchanan:
MARSH RUINS
by Amelia Groom

Pierre Huyghe:
UNTITLED
(HUMAN MASK)
by Mark Lewis

Helen Chadwick:
THE OVAL COURT
by Marina Warner

Donald Rodney:
AUTOICON
by Richard Birkett

Alfredo Jaar:
STUDIES ON HAPPINESS
by Edward A. Vazquez

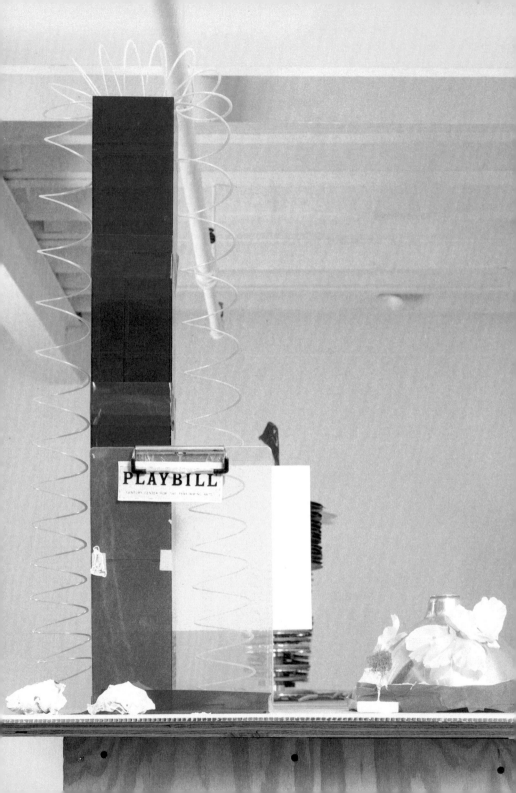